*Thank you for purchasing 'Sue's Doodles'! Whether you are already avid about coloring or this book is your maiden voyage into the world of coloring, you will soon discover the calming and relaxing benefits this hobby will have on you which I refer to as Chillaxing effect!*

*Your journey begins with large, loose shapes, easing you into more complex and intense doodles. Just as becoming physically fit requires you to begin with the basic exercises and gradually increasing the intensity of your workout, the same could be said for entering the adult world of coloring.*

*You will find several intentionally left blank pages throughout the book. They are included for you to test your color choices before permanently committing a color to an actual doodle. Remember, there is no right or wrong color selection for these doodles, there is only your choice of color that will make these pictures your own.*

*A huge thank you to all my family & friends for being my very own cheering section! A shout out to the Redwood City Fed Ex Office Steve, Moises and crew for tolerating my late evening visits requesting copies of my artwork ASAP. A special thank you to Shellie Hatfield. without her encouragement and support, this project may never have been completed. Last, but not least, my husband, Jerry for his belief in my abilities that never wavered and understanding my endless hours devoted to drawing. I thank you all!*

# Sue's Doodles

*Sue Pellizzer*

*Calming, Stress Relieving, Coloring Book for Adults*

# Chillax

*Enjoy the journey!*

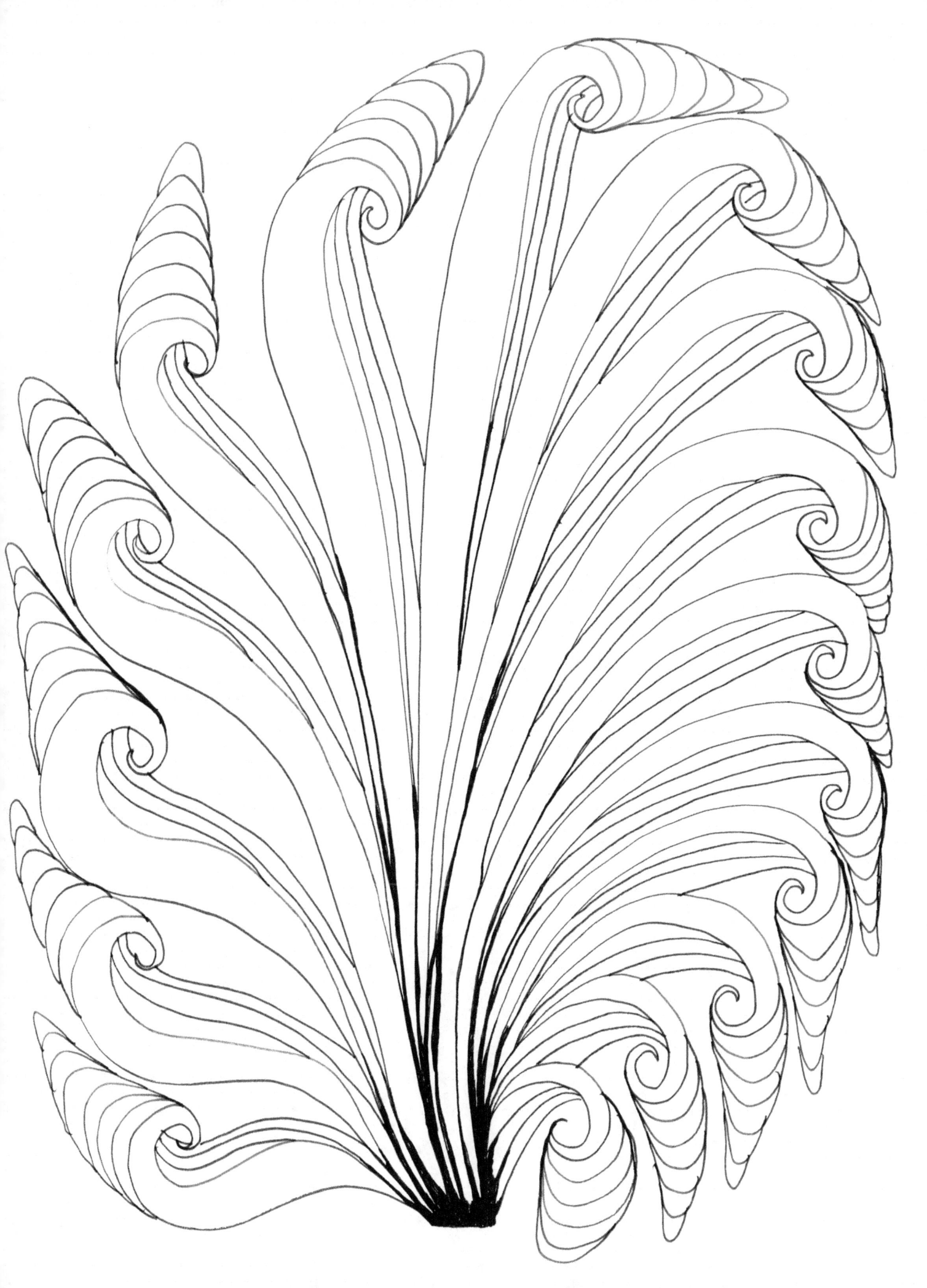

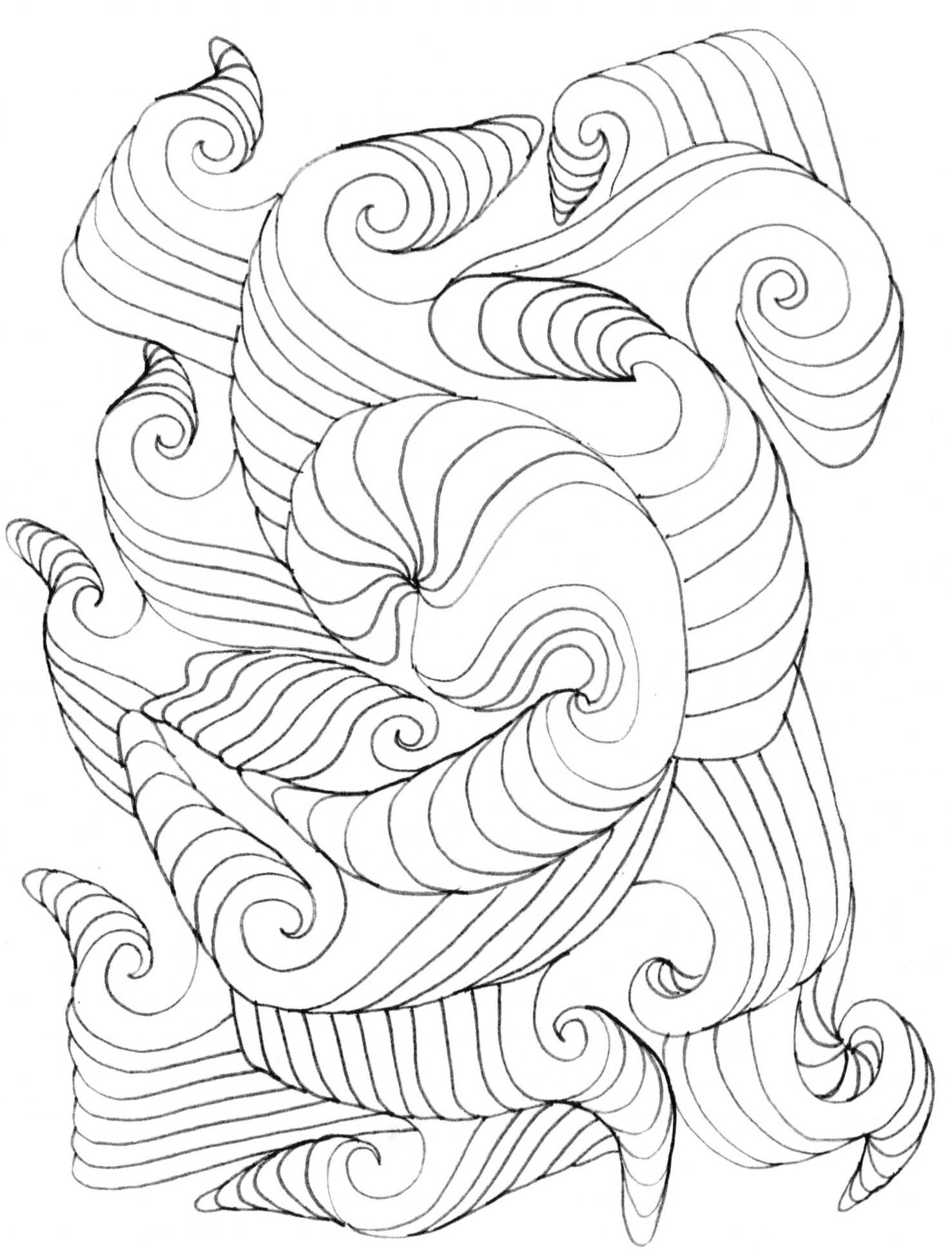

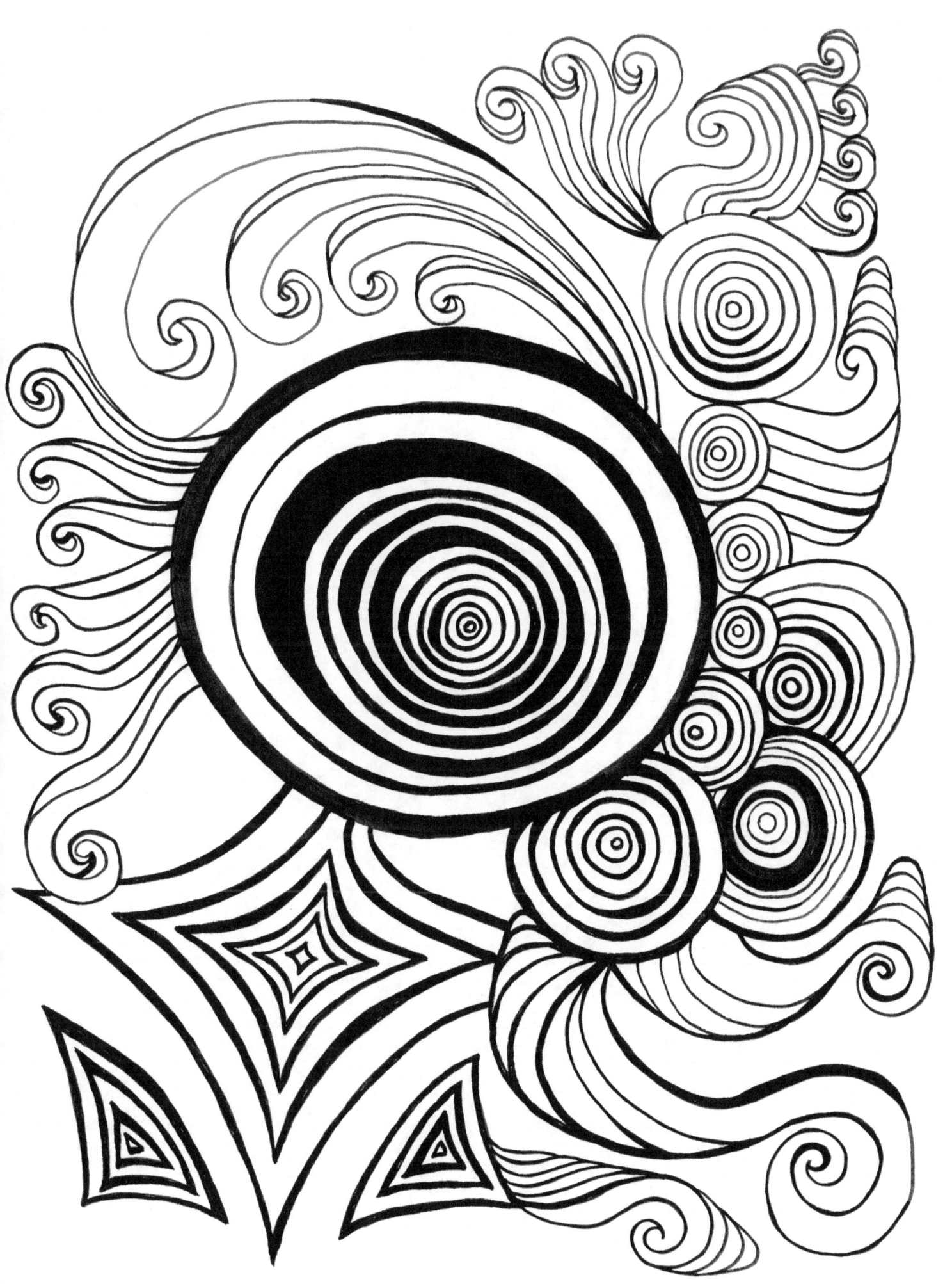

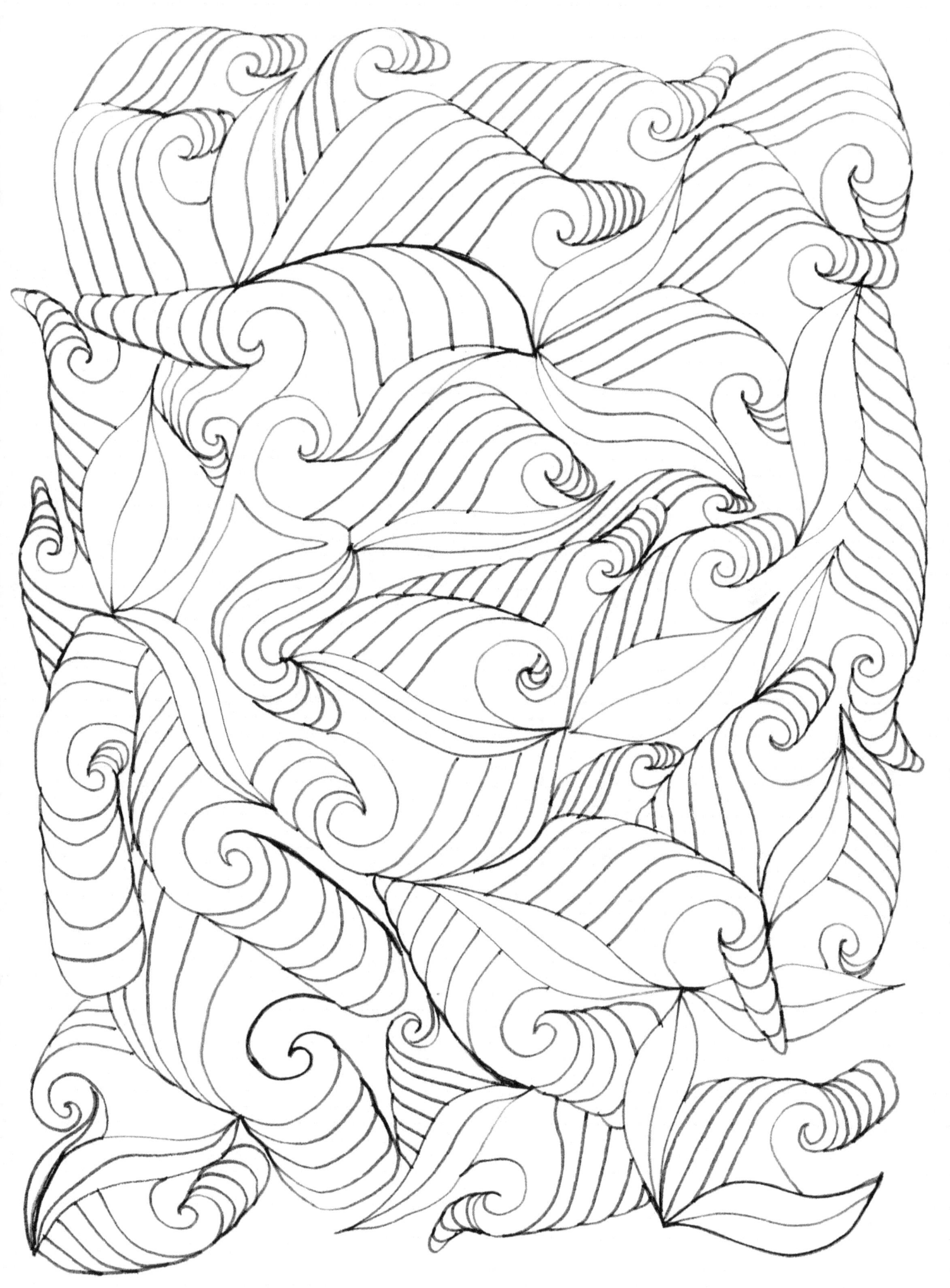

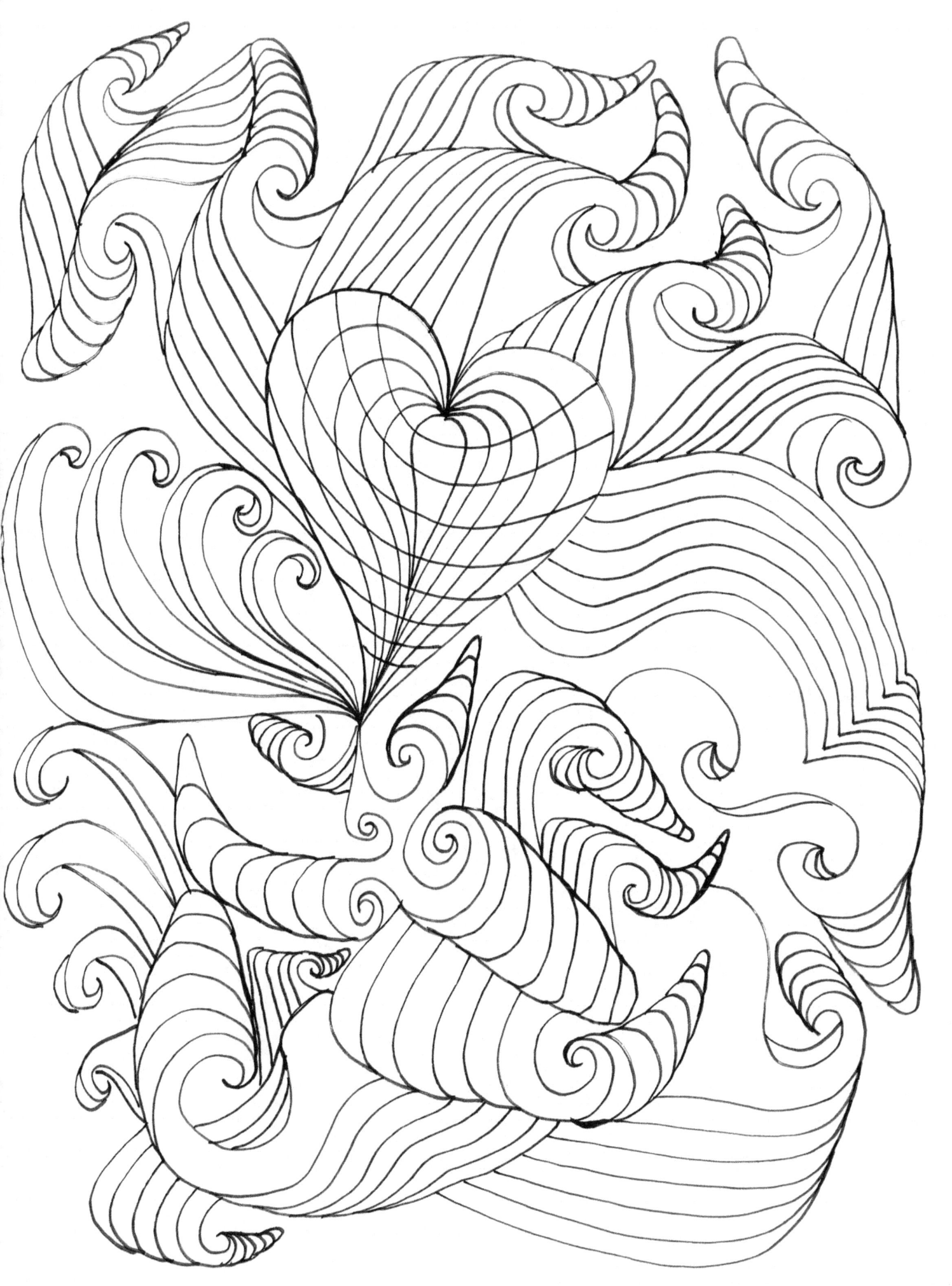

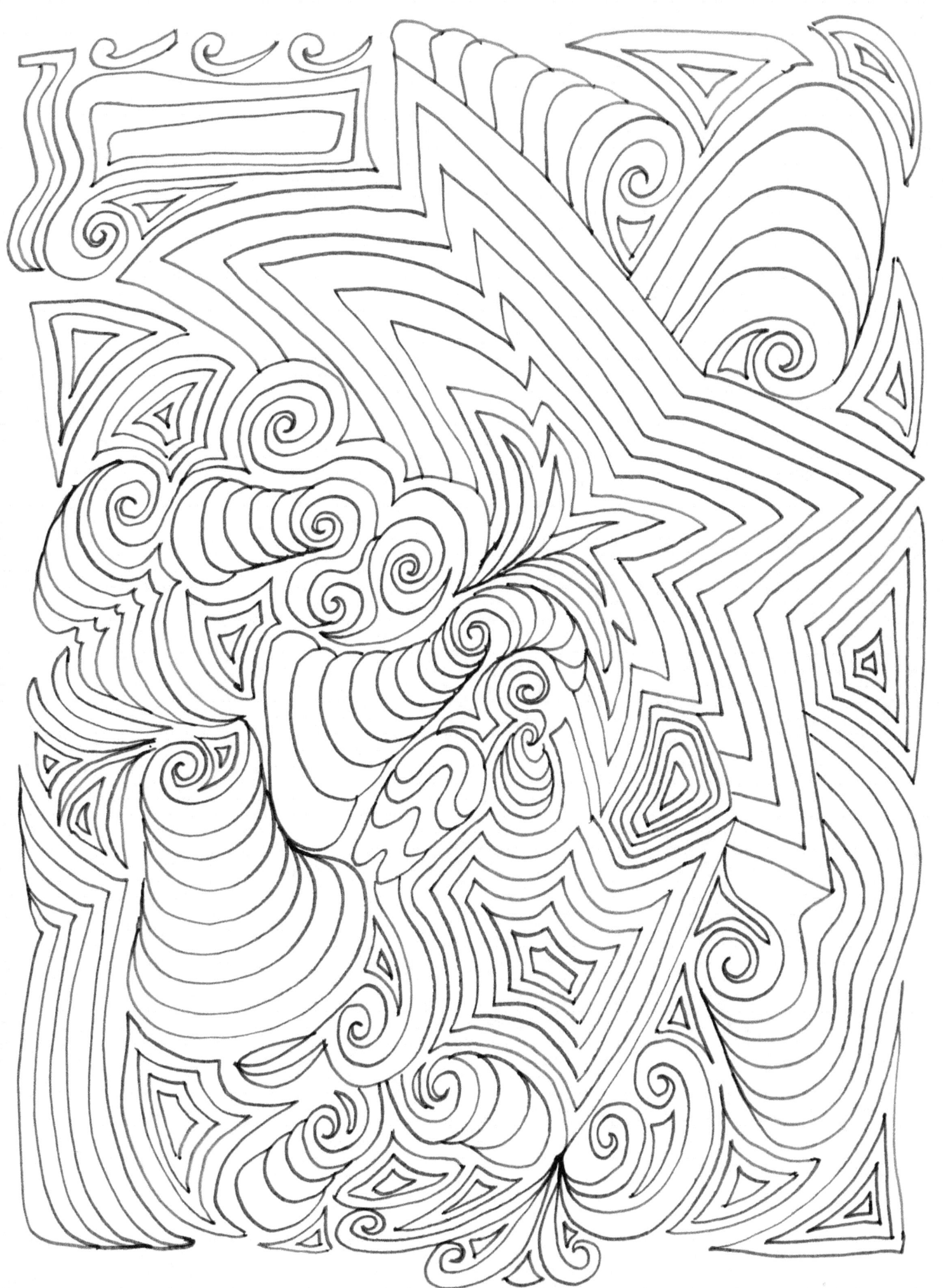

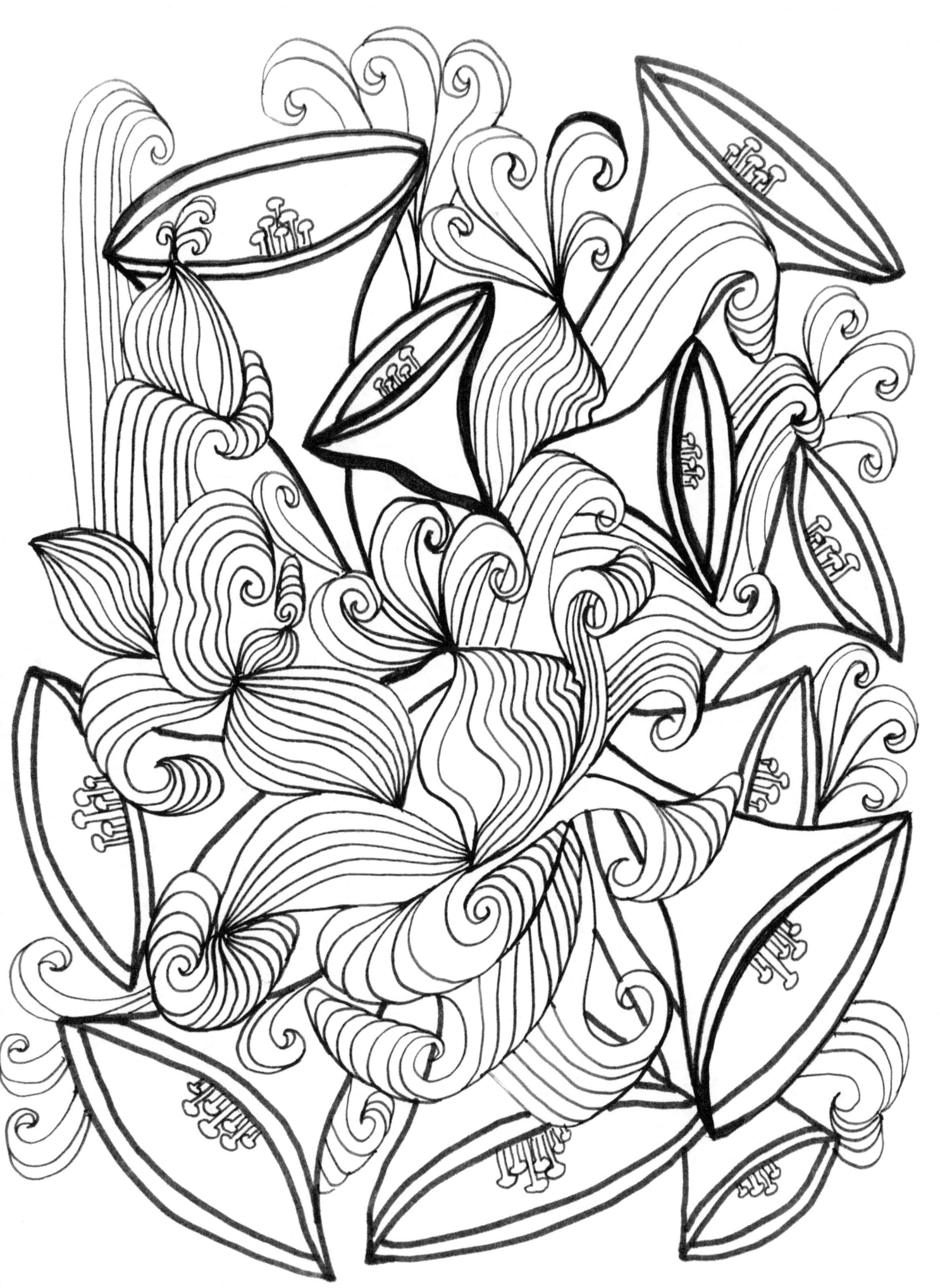

***This page intentionally left Blank
to test your colors***

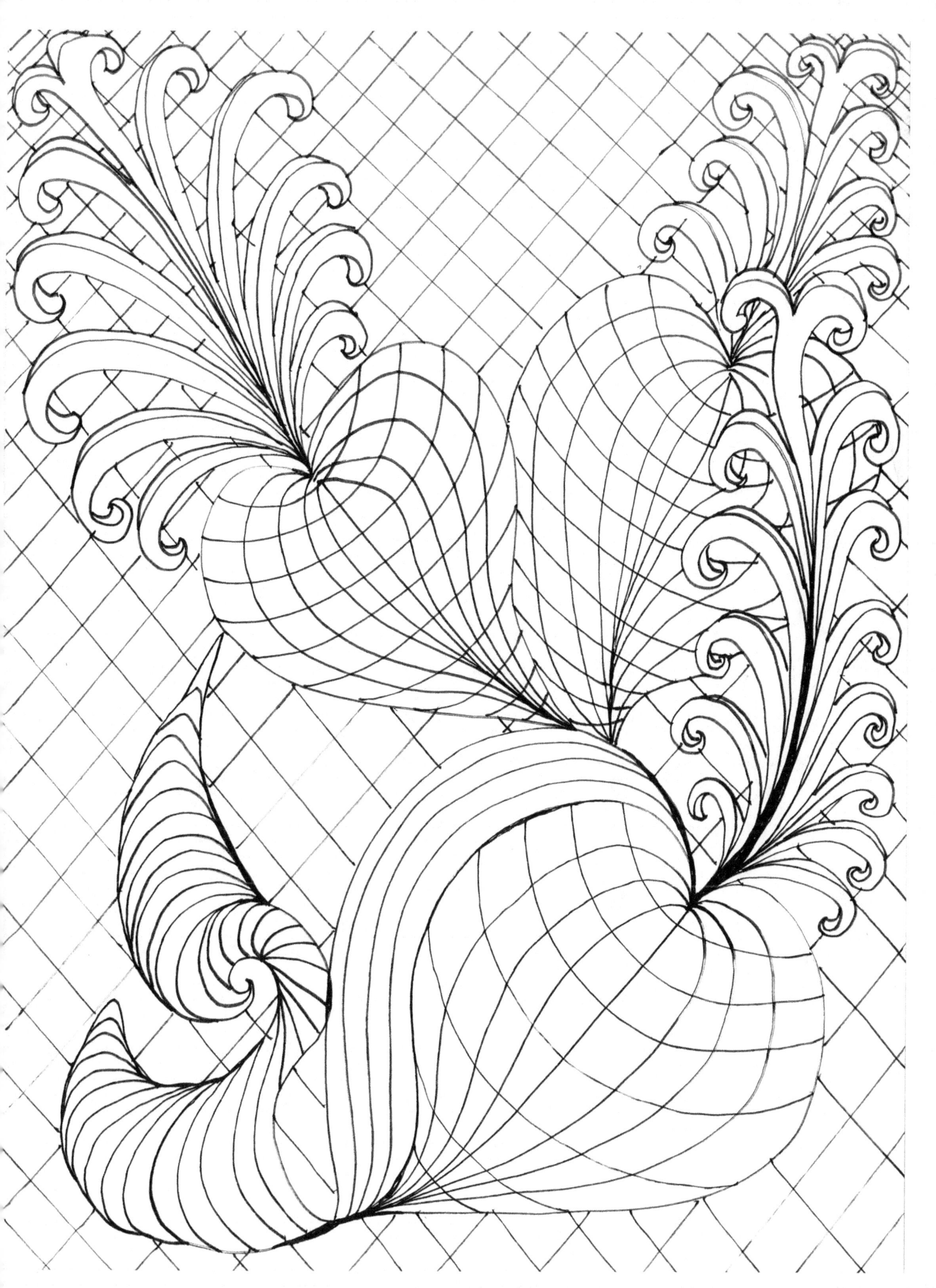

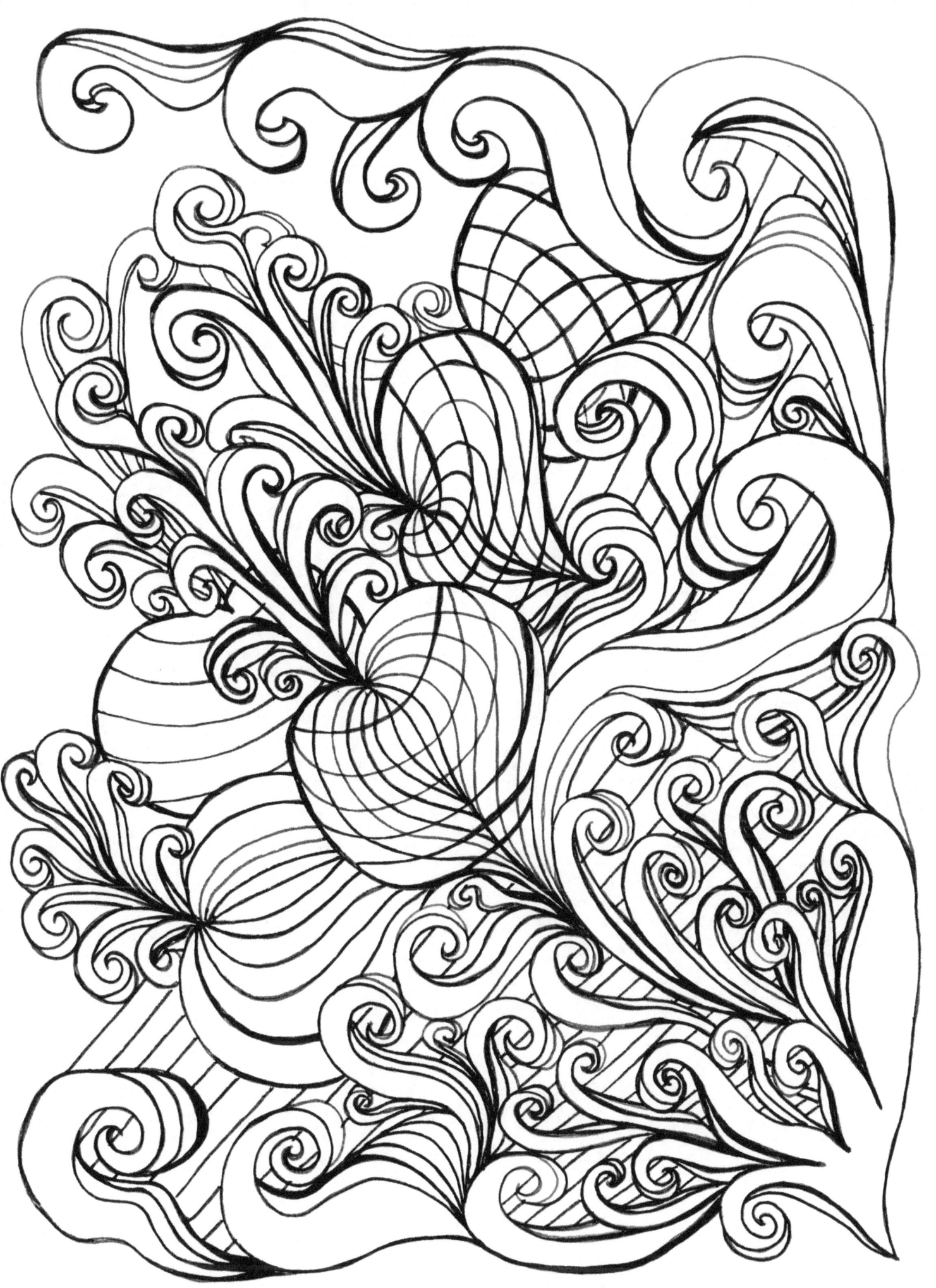

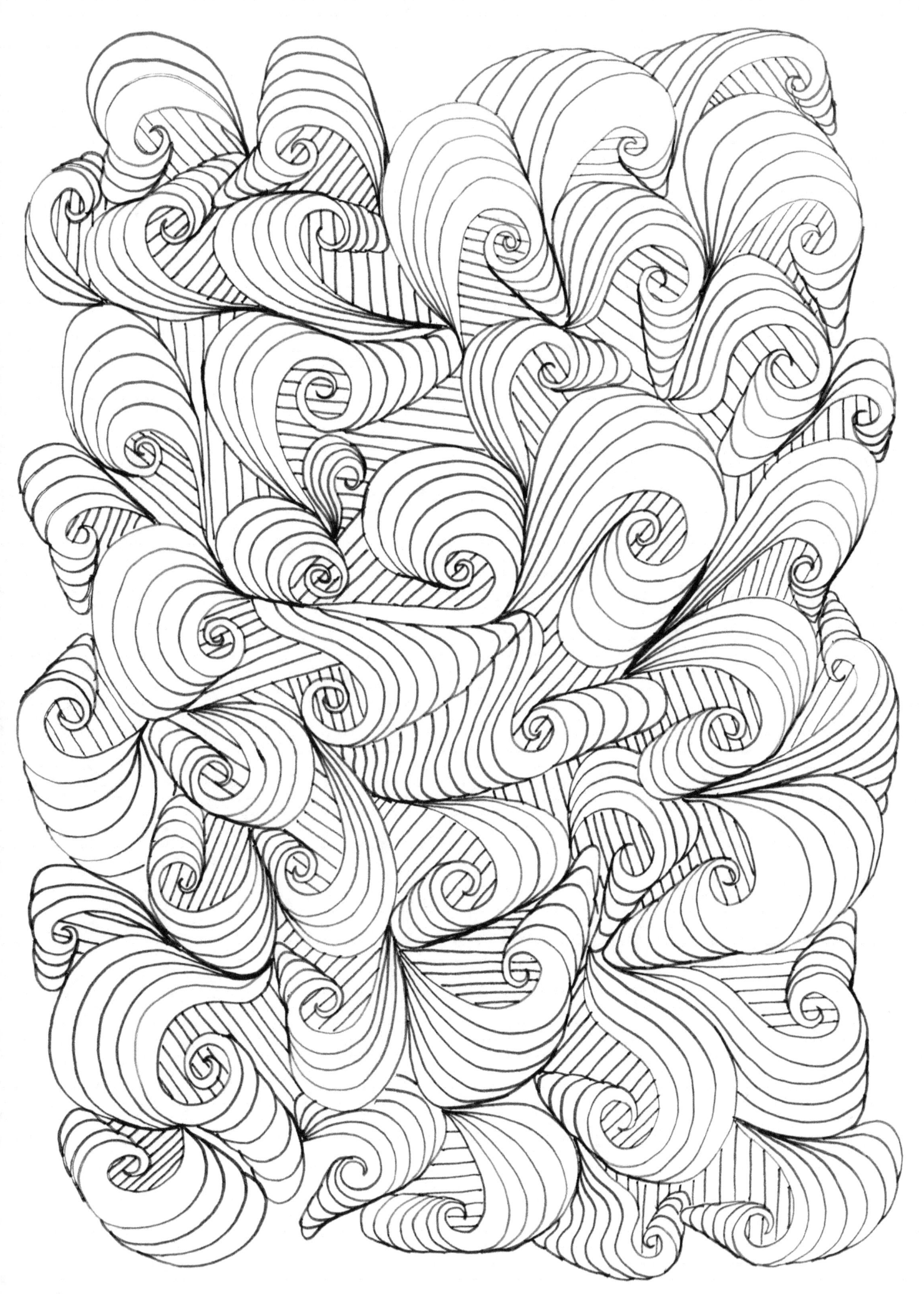

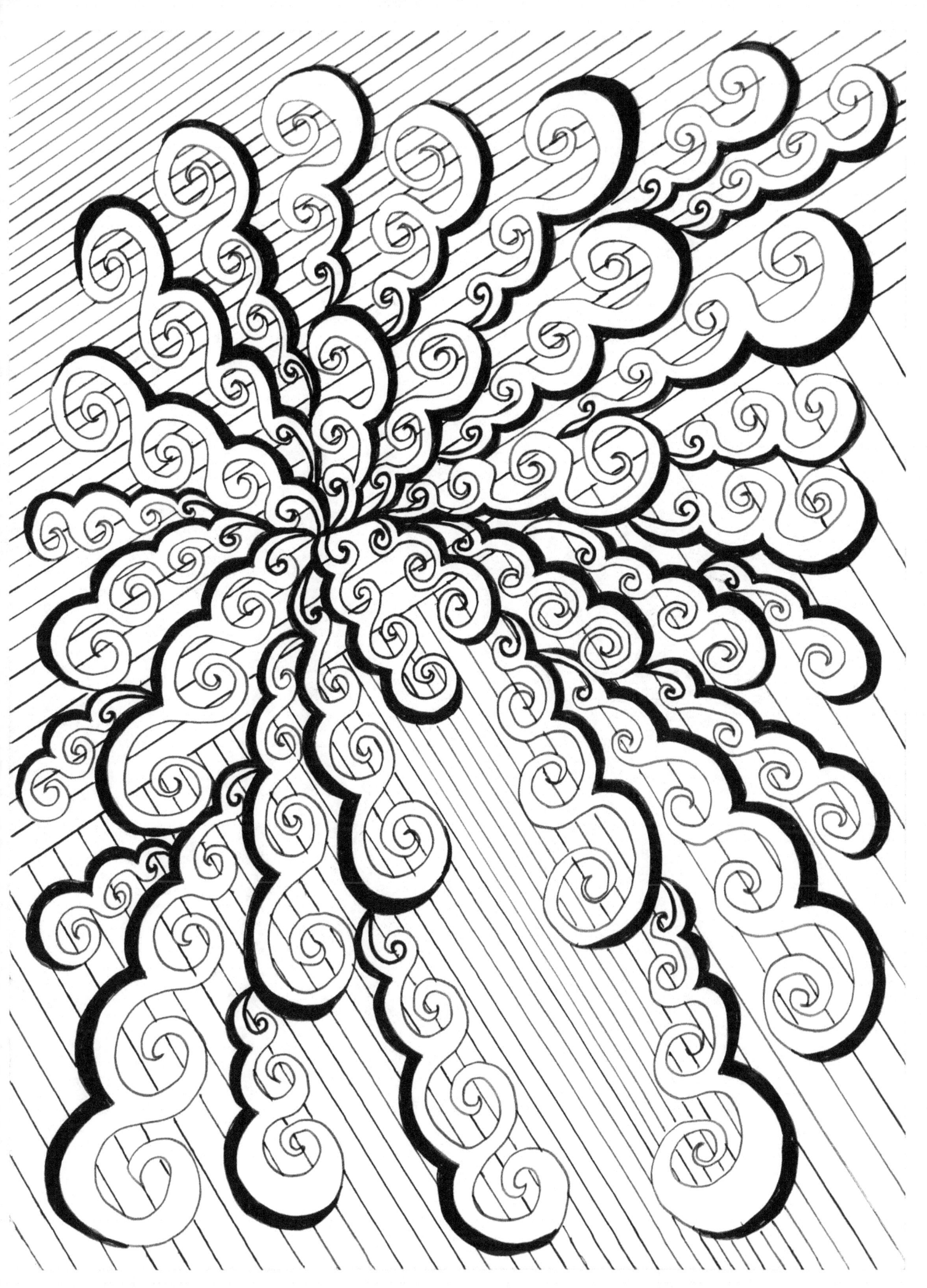

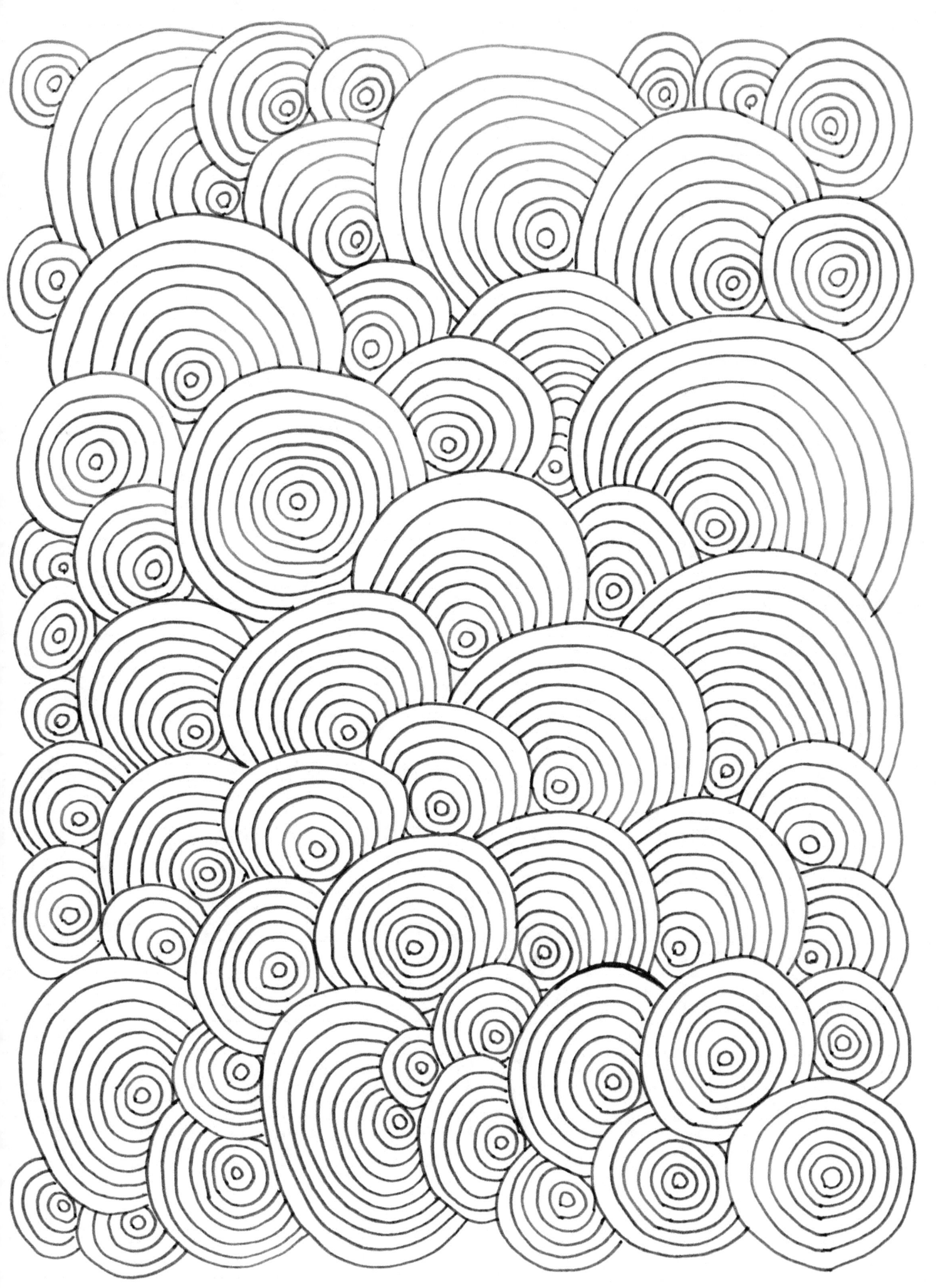

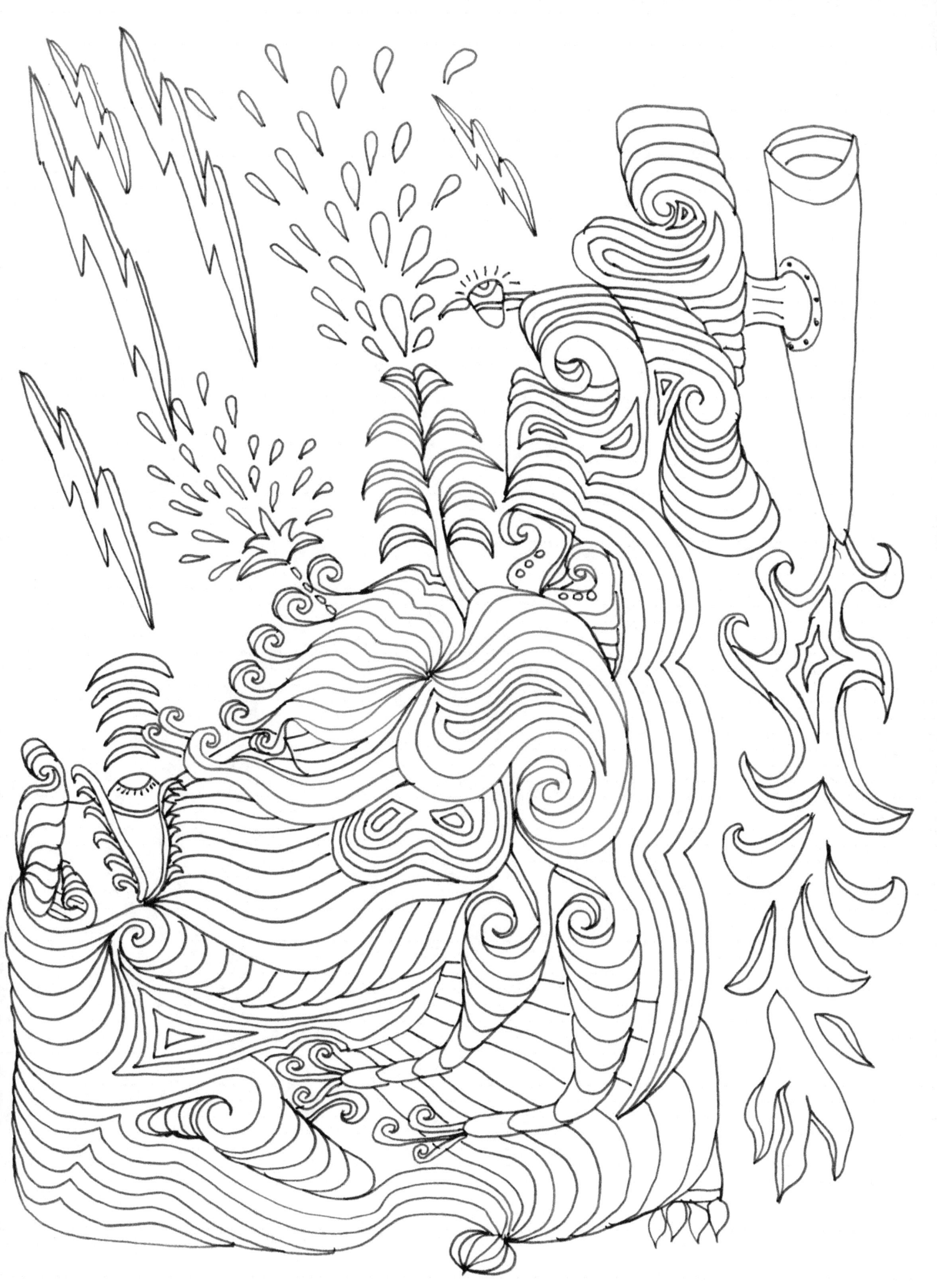

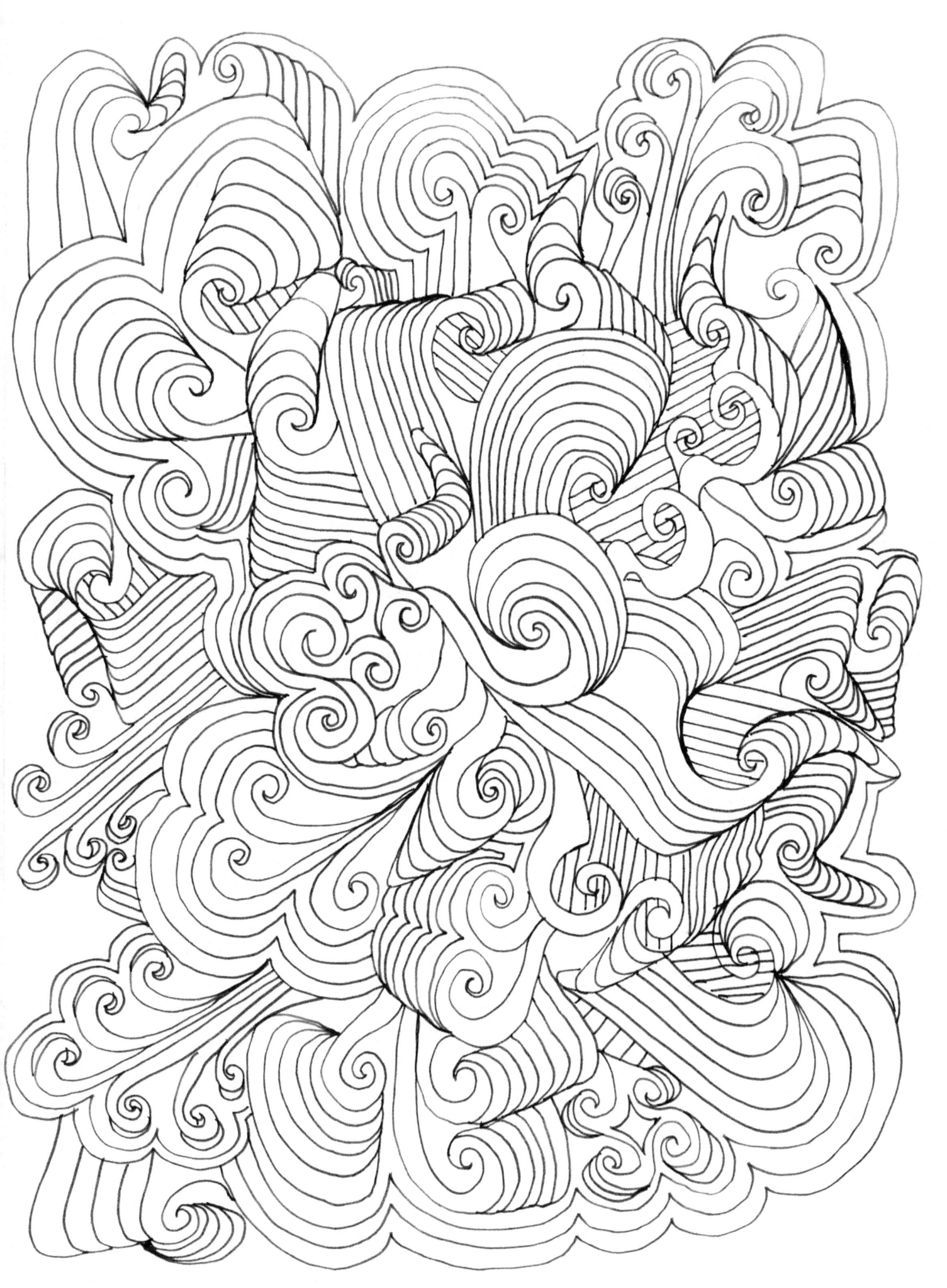

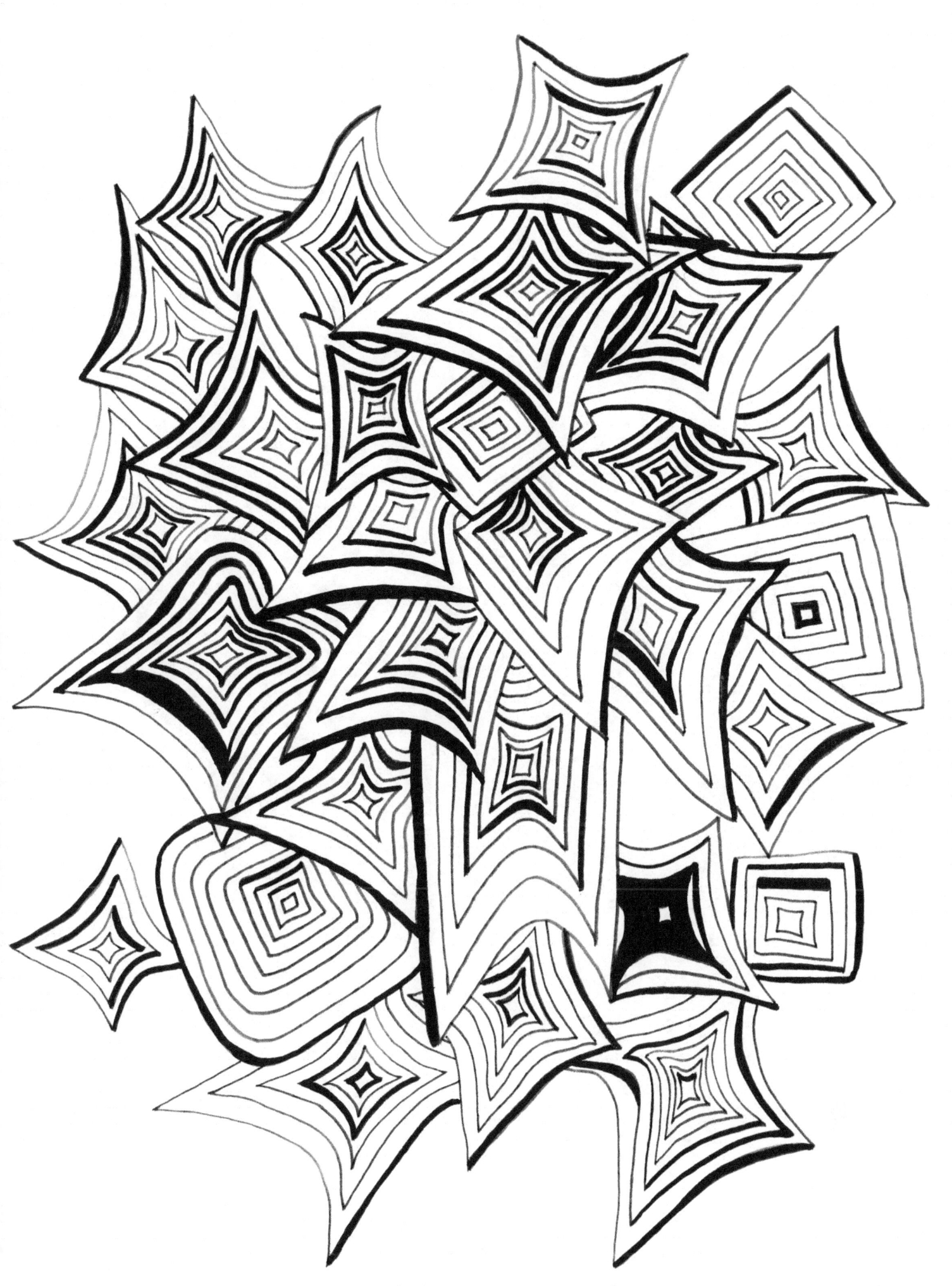

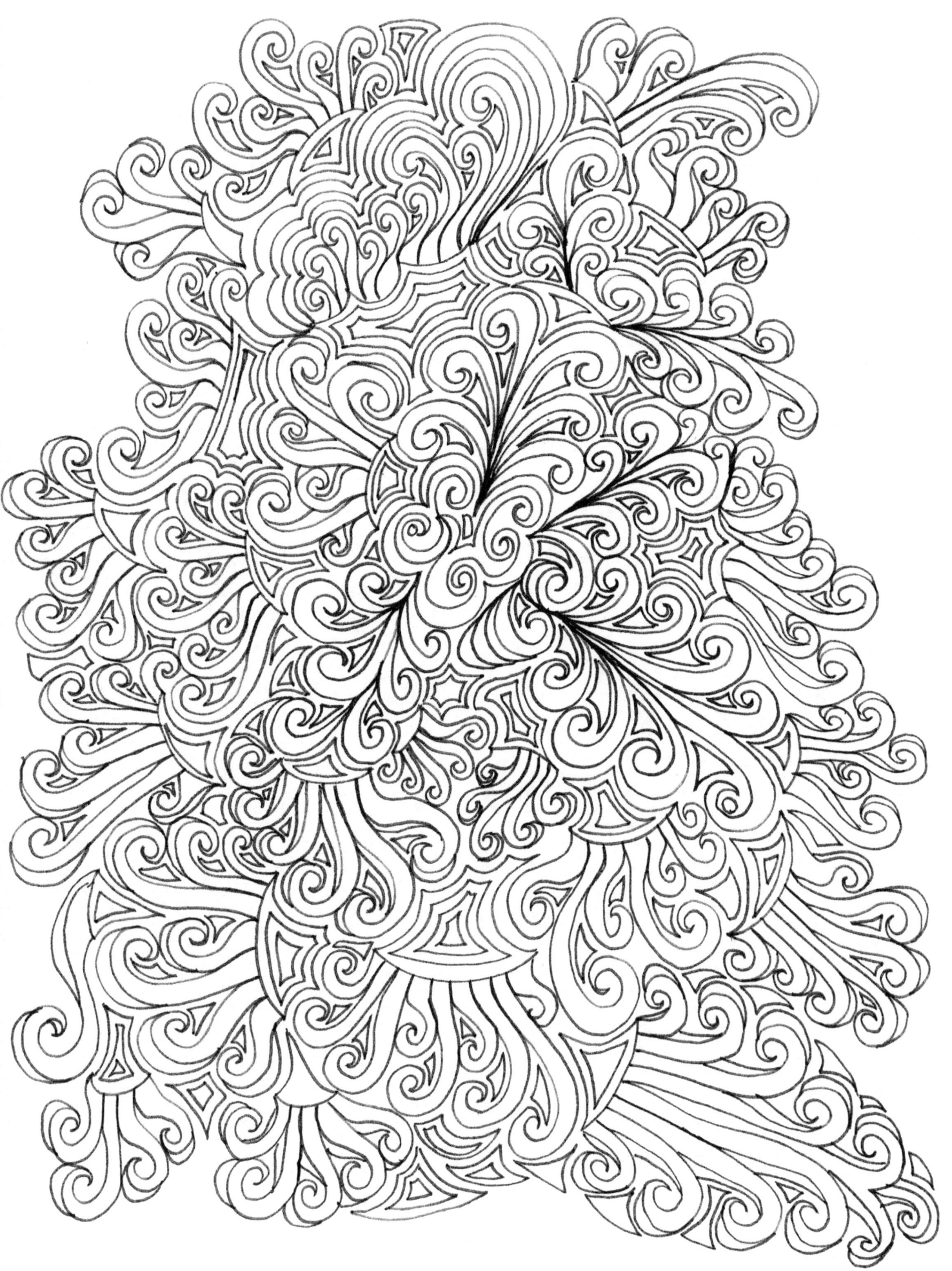

**This page intentionally left Blank
to test your colors**

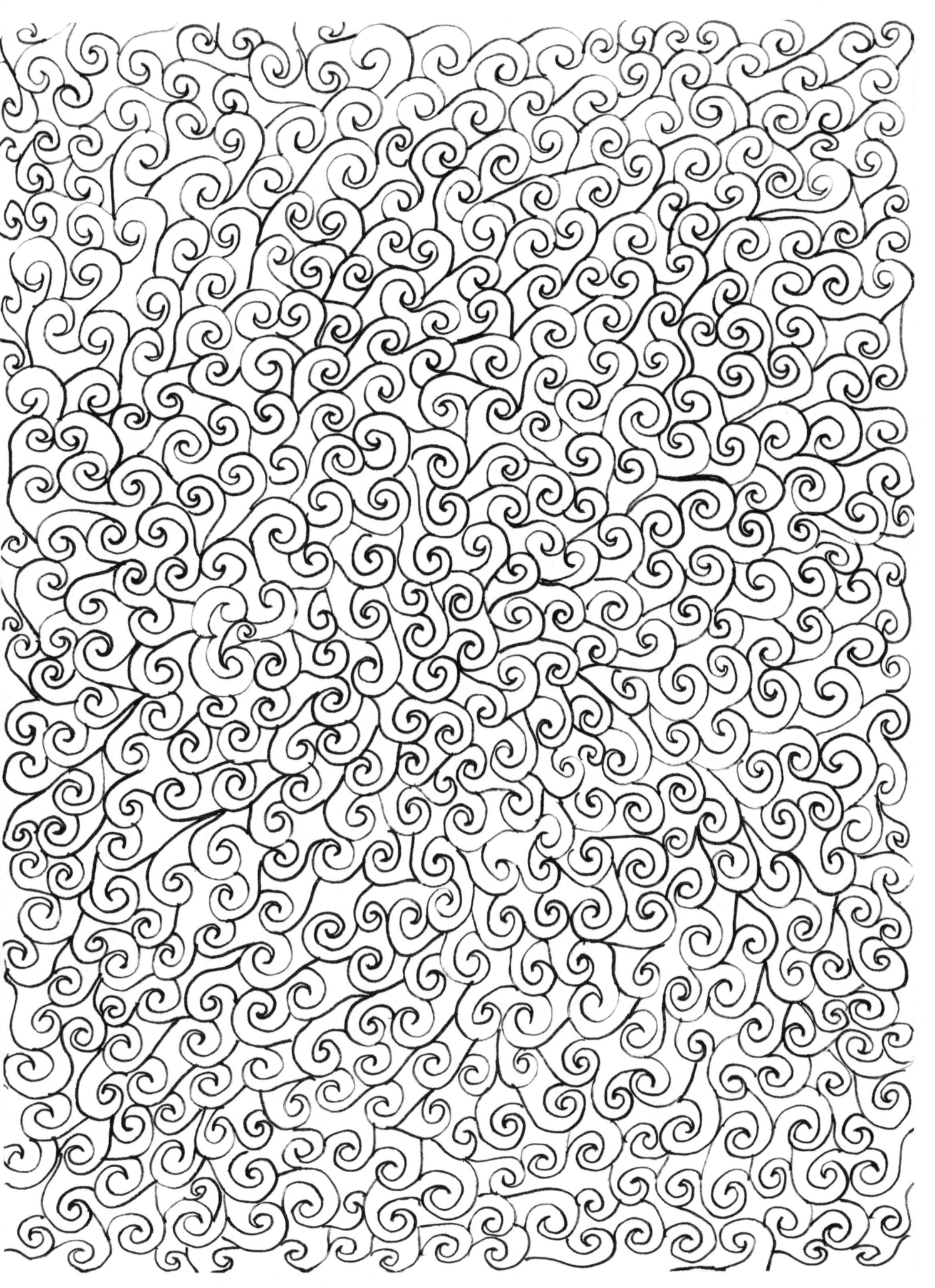

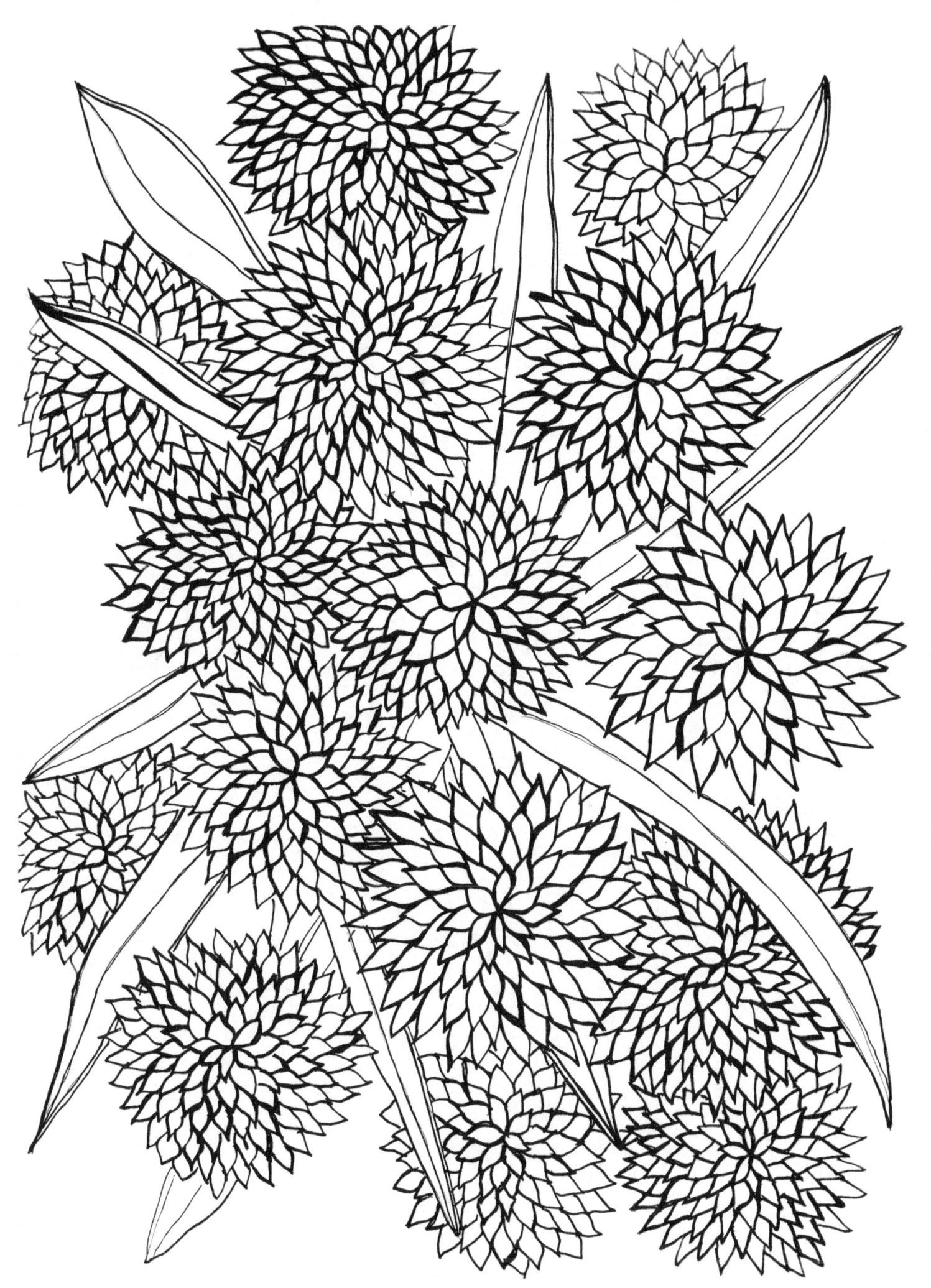

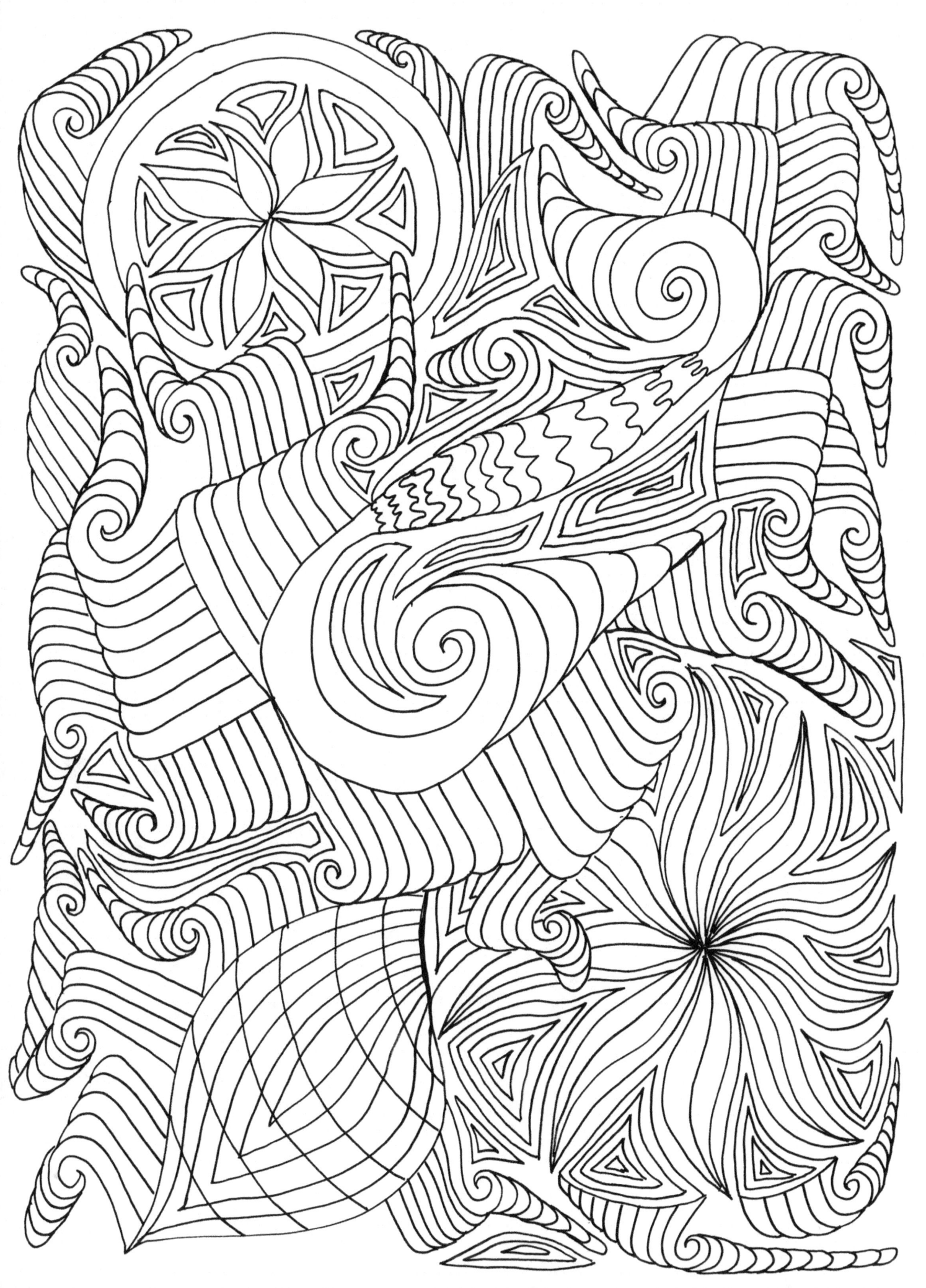

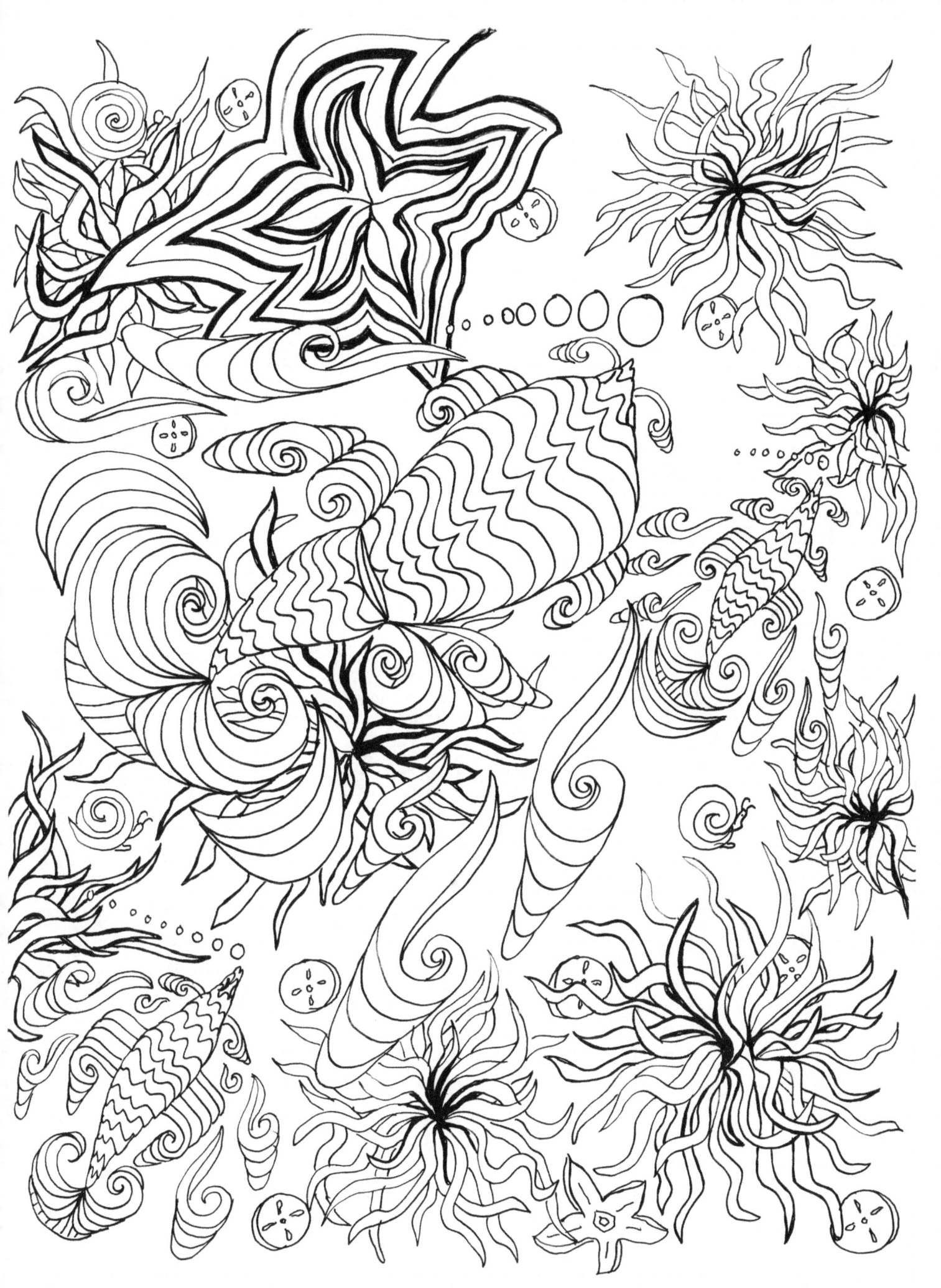

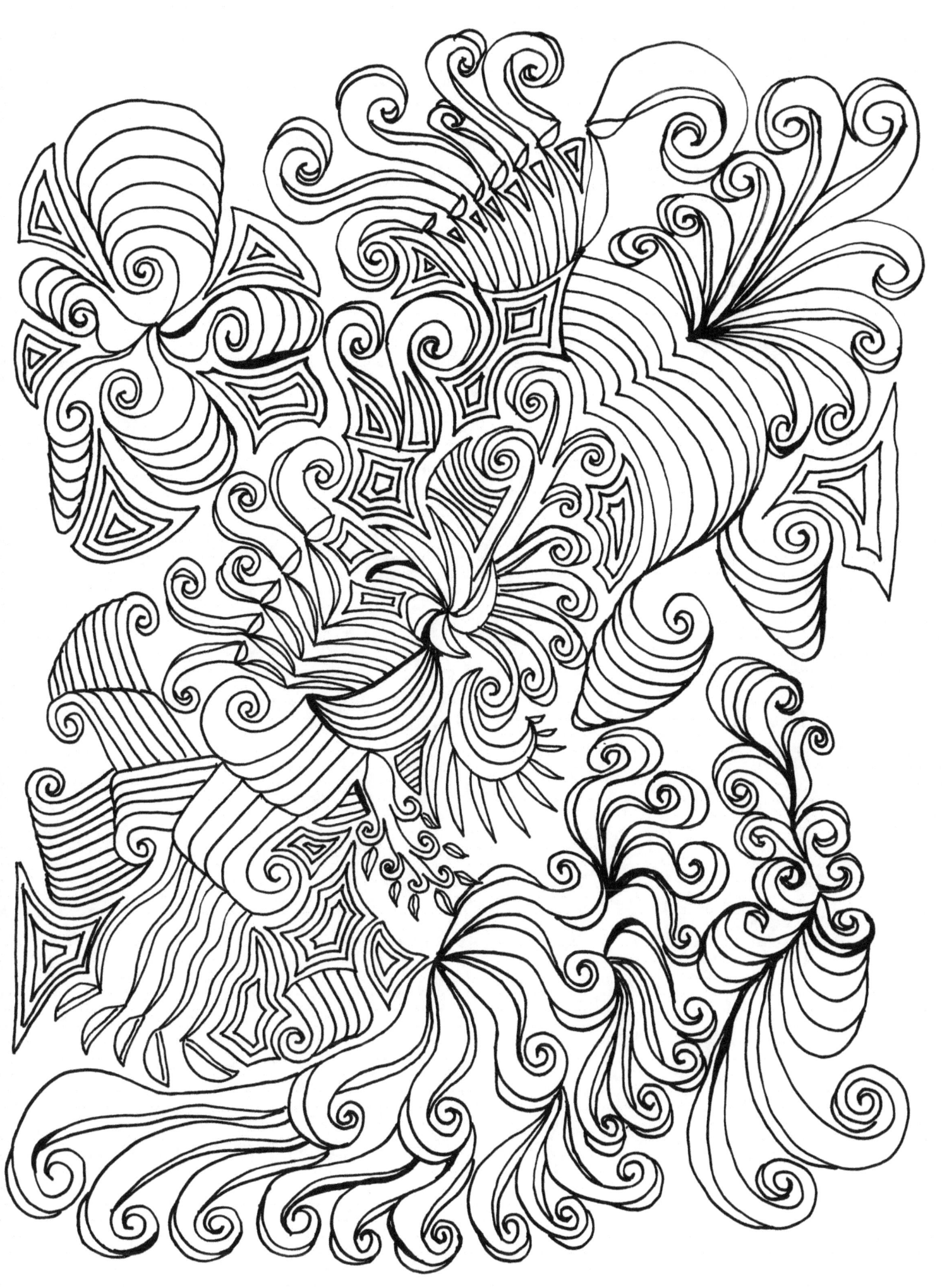

# This page intentionally left Blank
## to test your colors

You have already been exposed earlier in this book to one of my favorite doodles I refer to as my "Kitchen Beets". In the following pages you will find more kitchen beets and several copies of your basic kitchen beet, giving you the opportunity to add your own design. No rules or guidelines here, except to just make it your own!

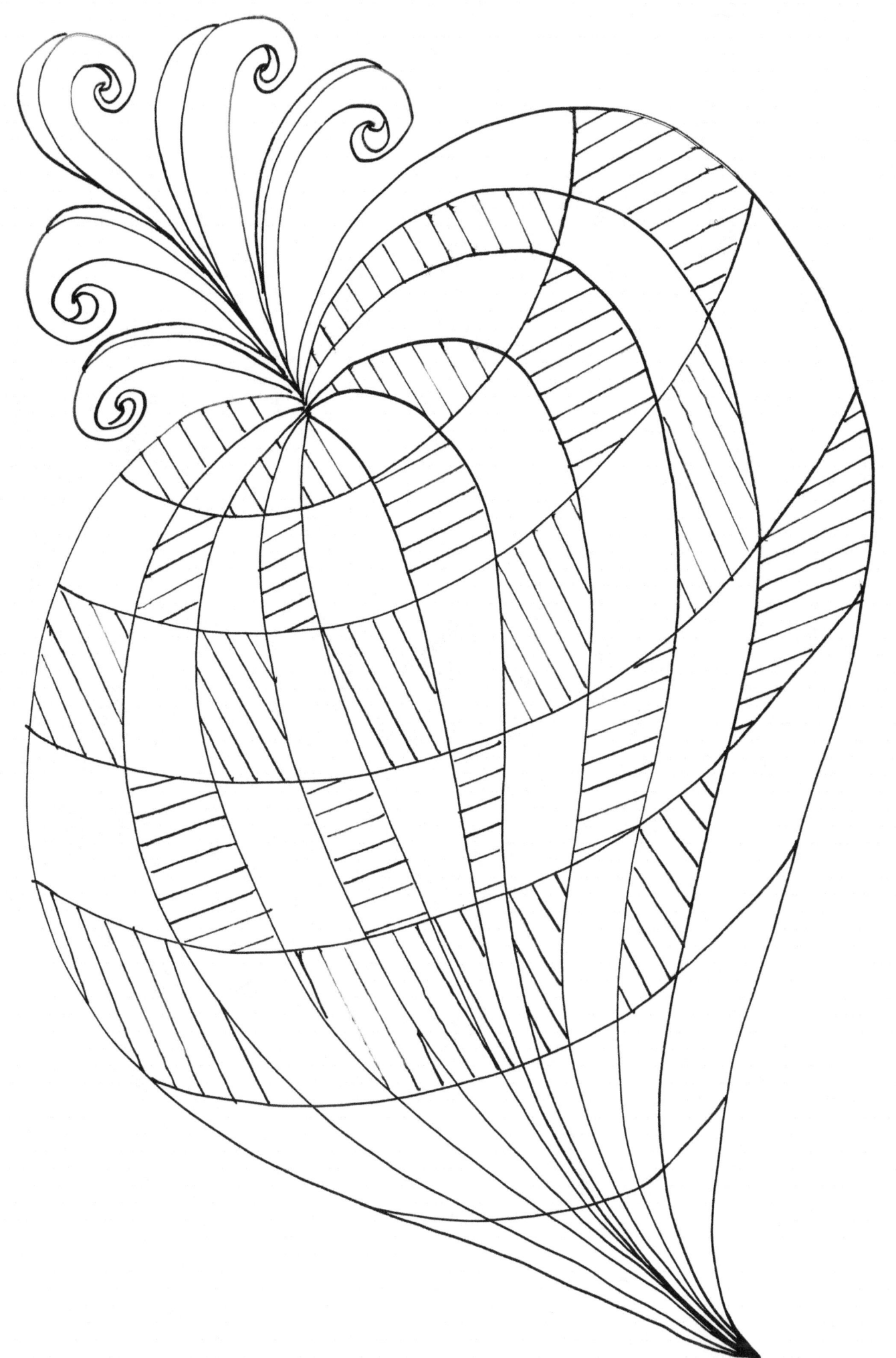

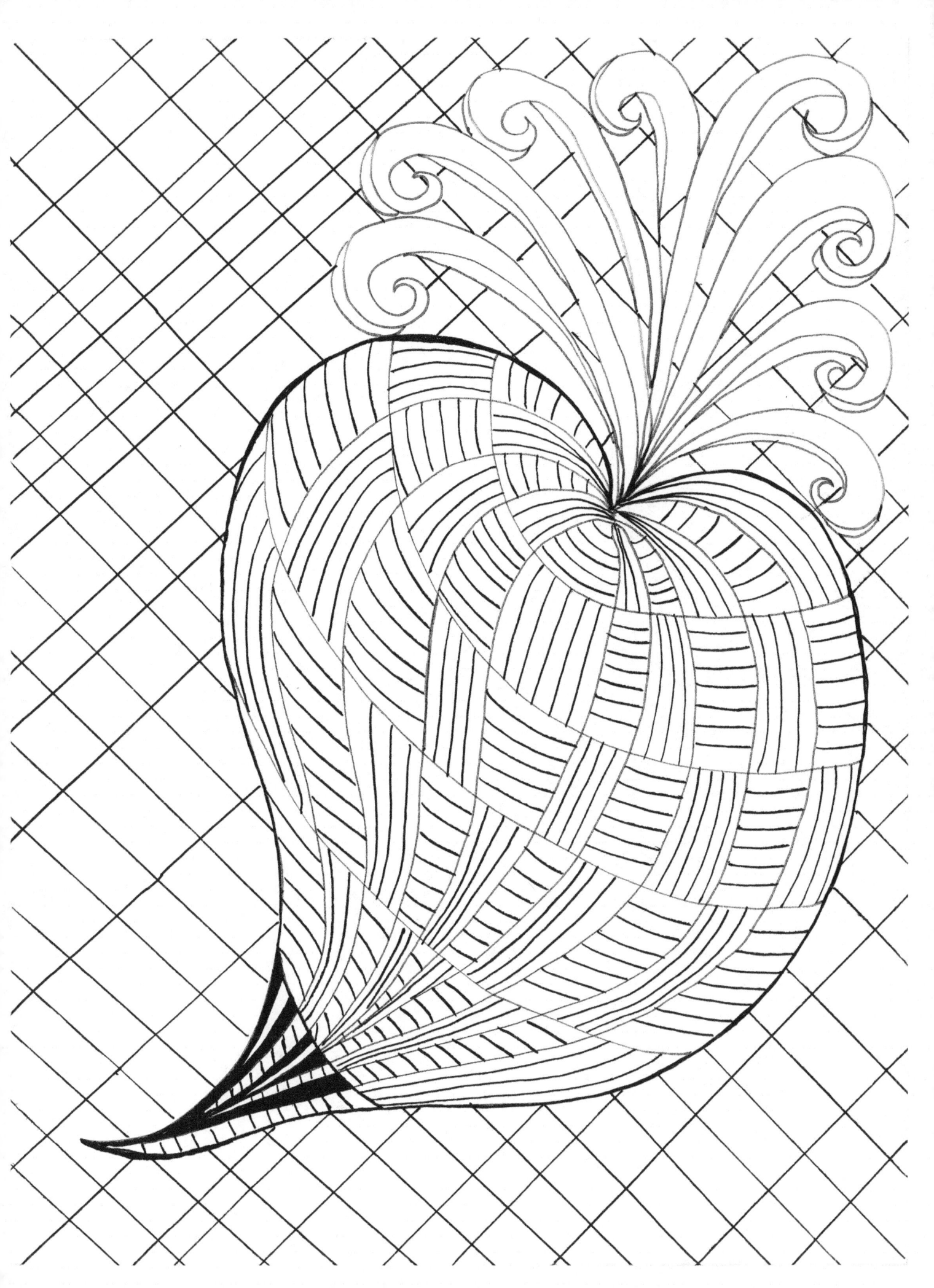

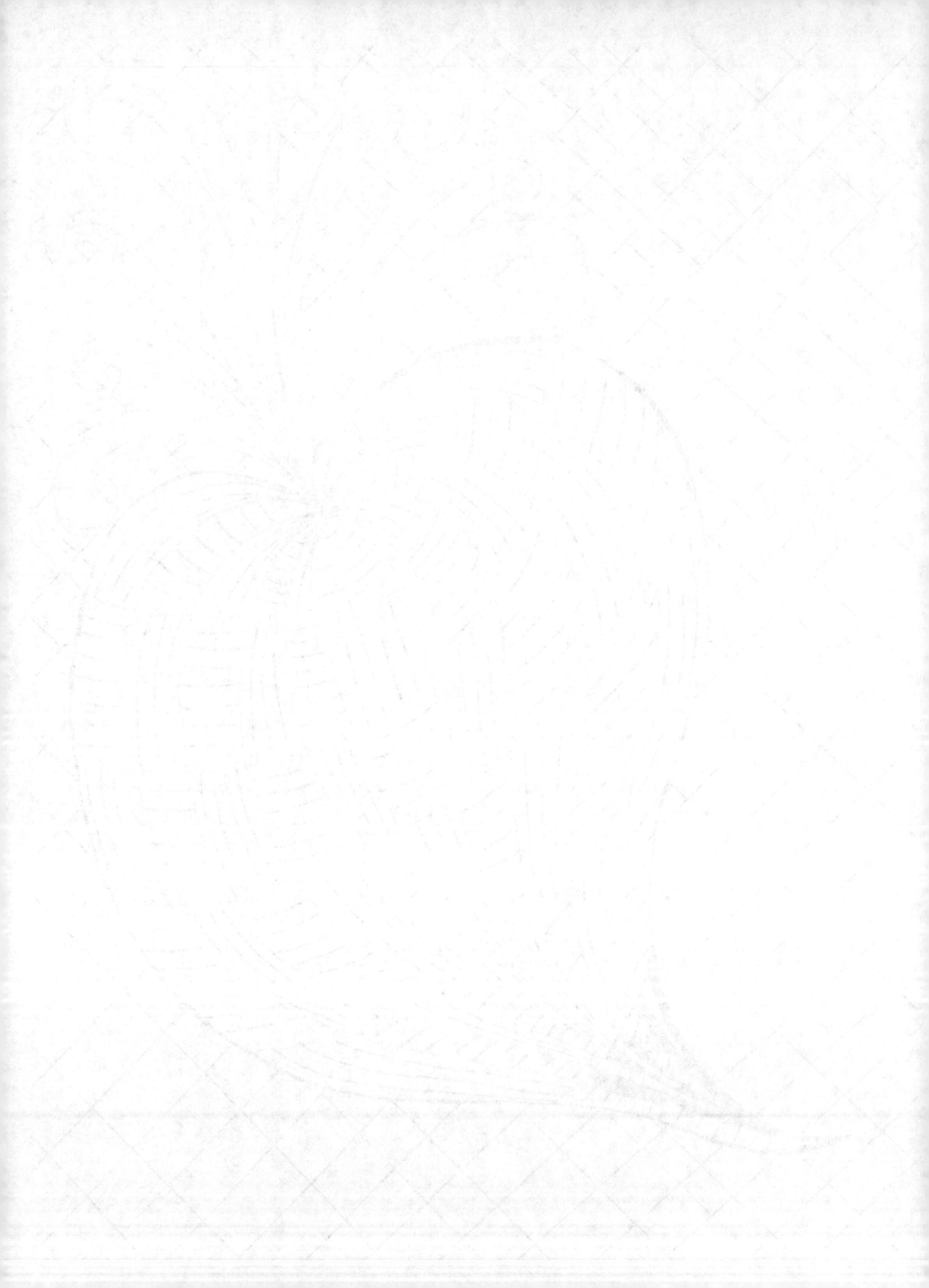

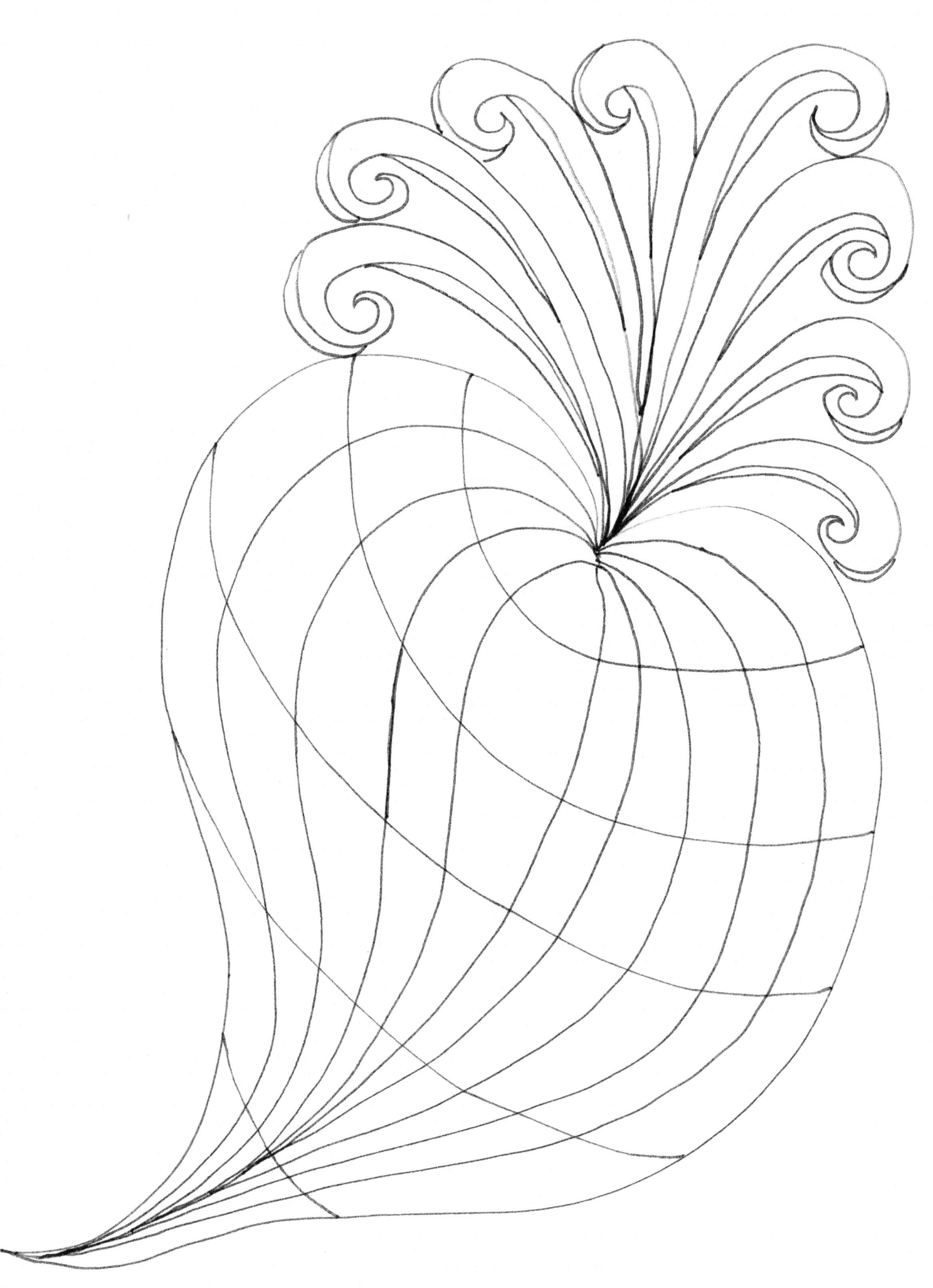

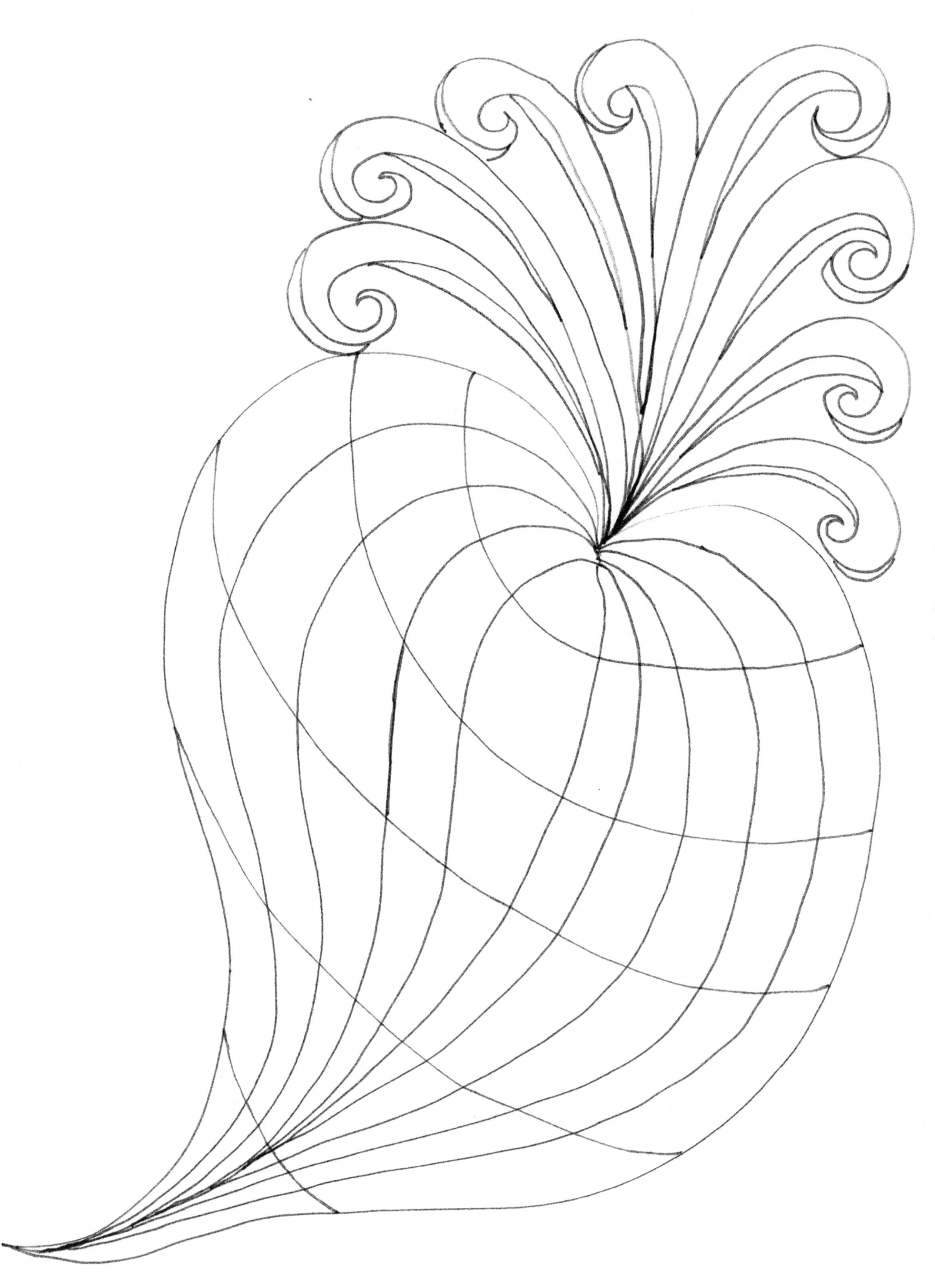

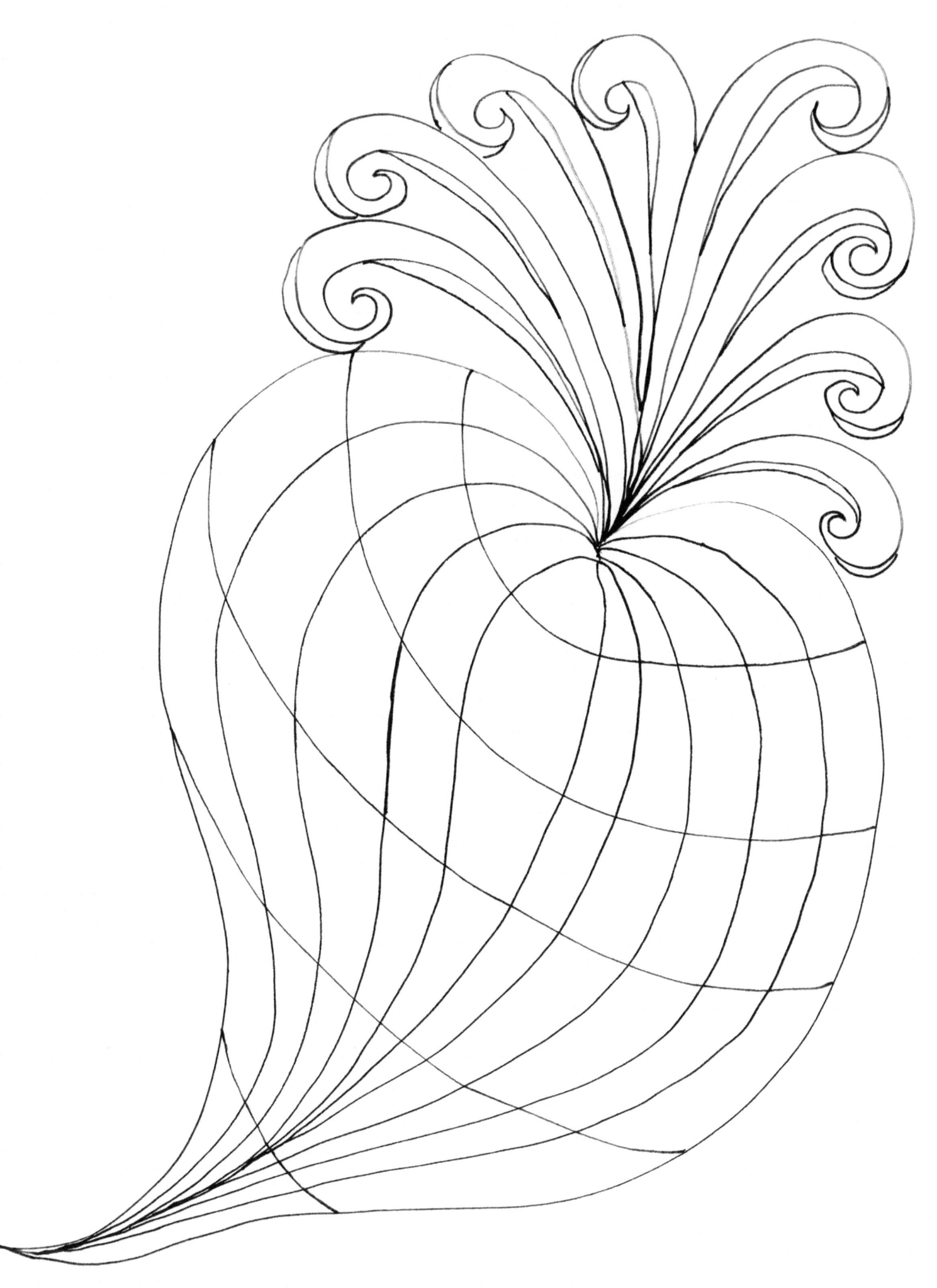

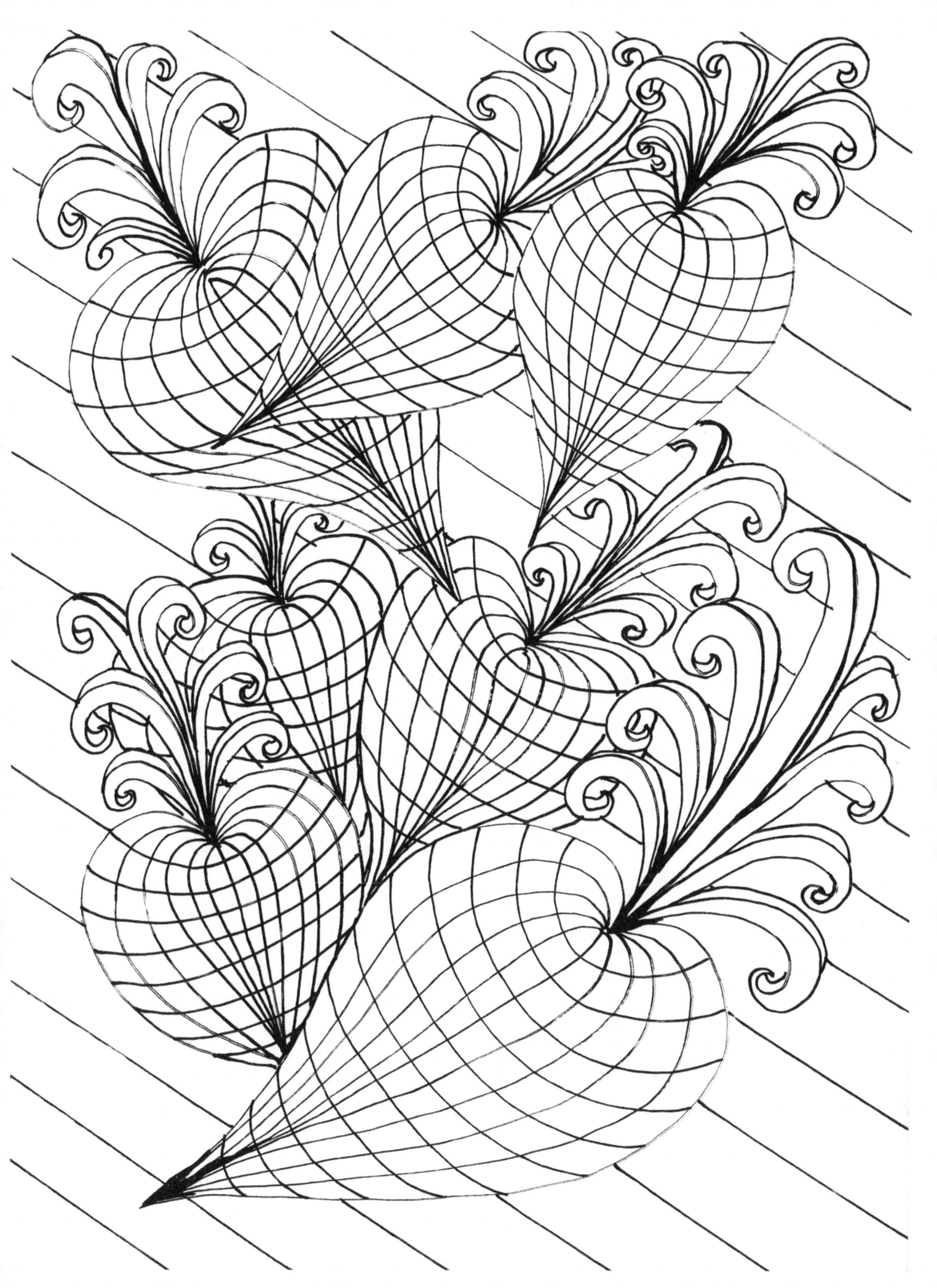

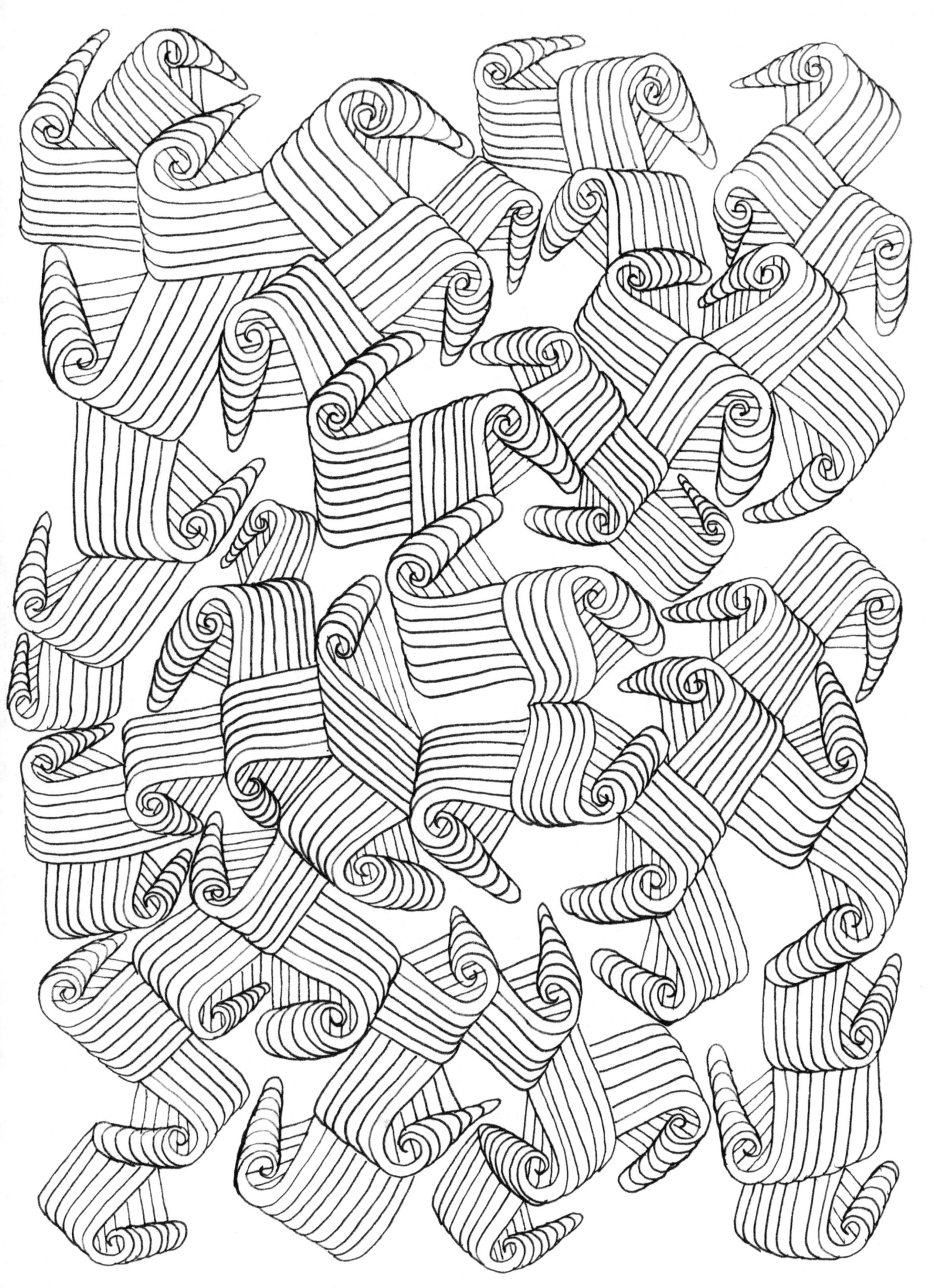

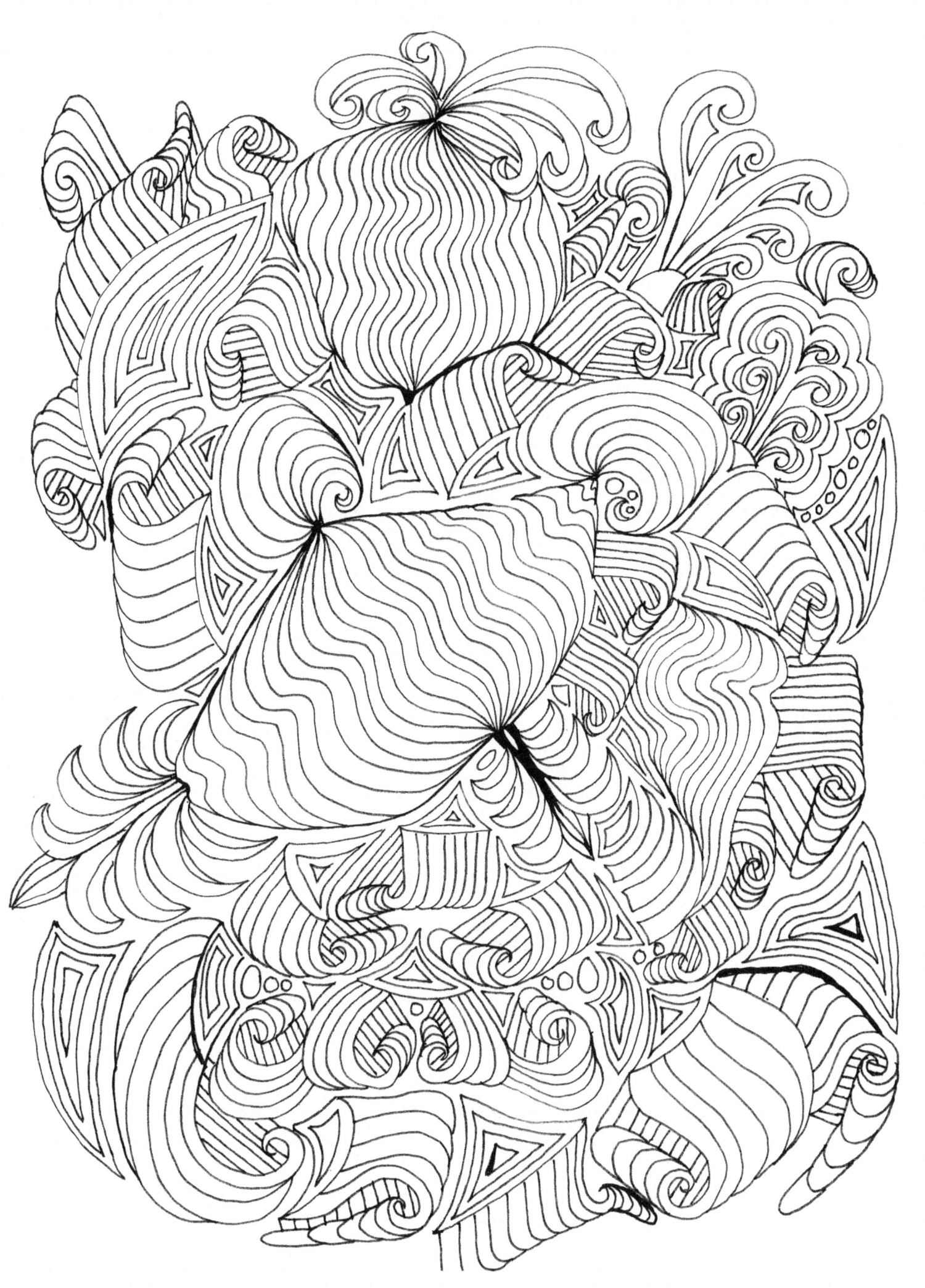

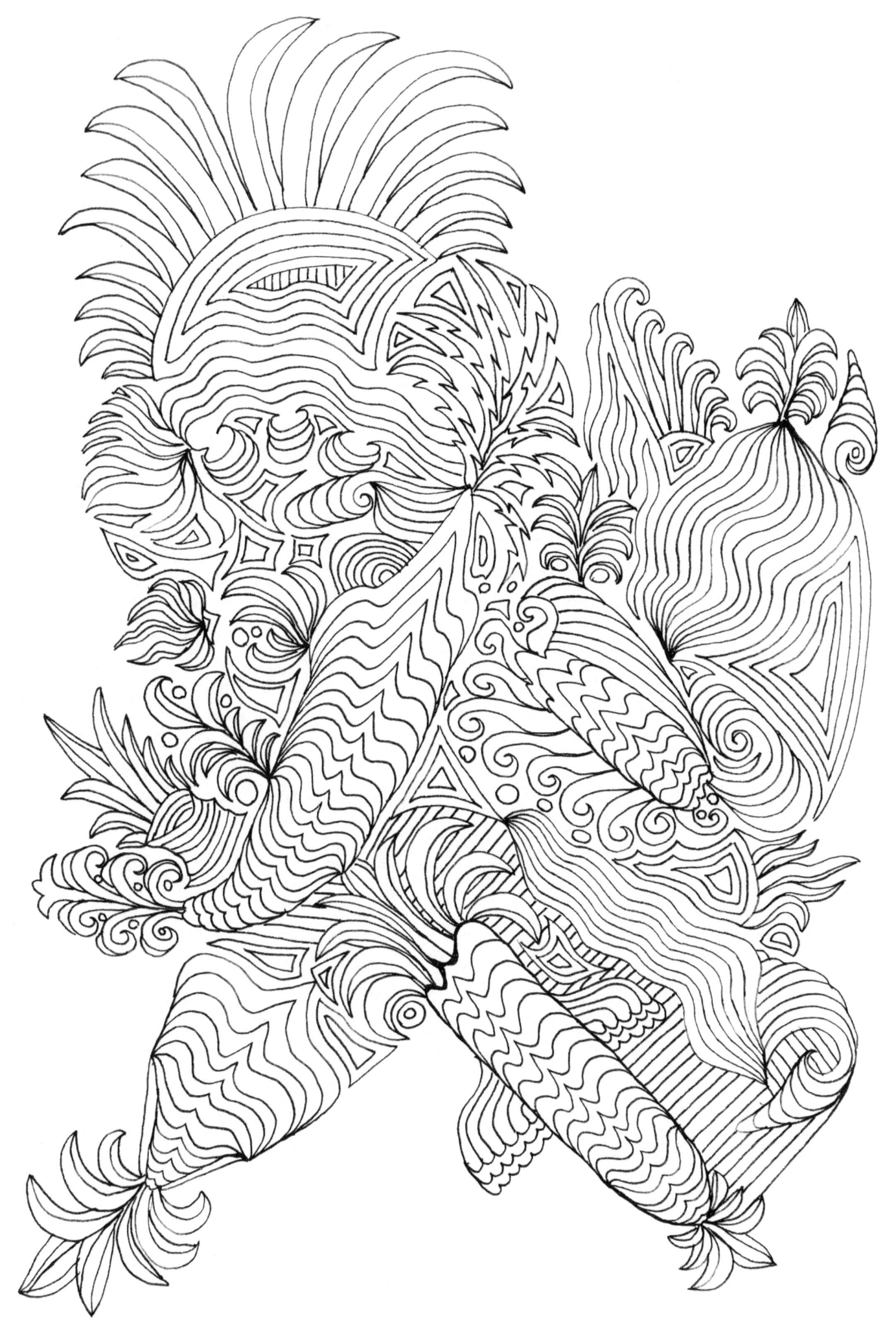

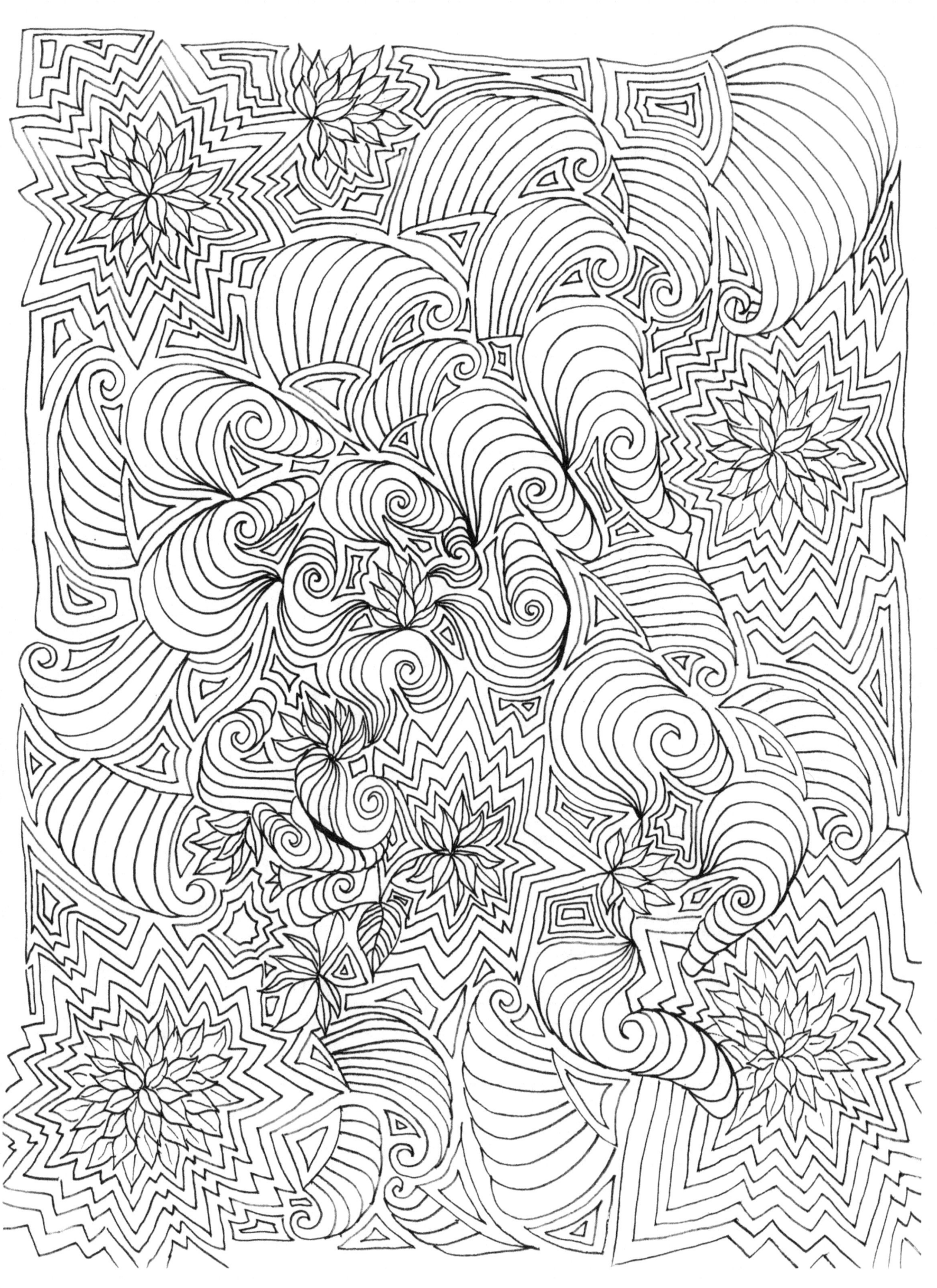

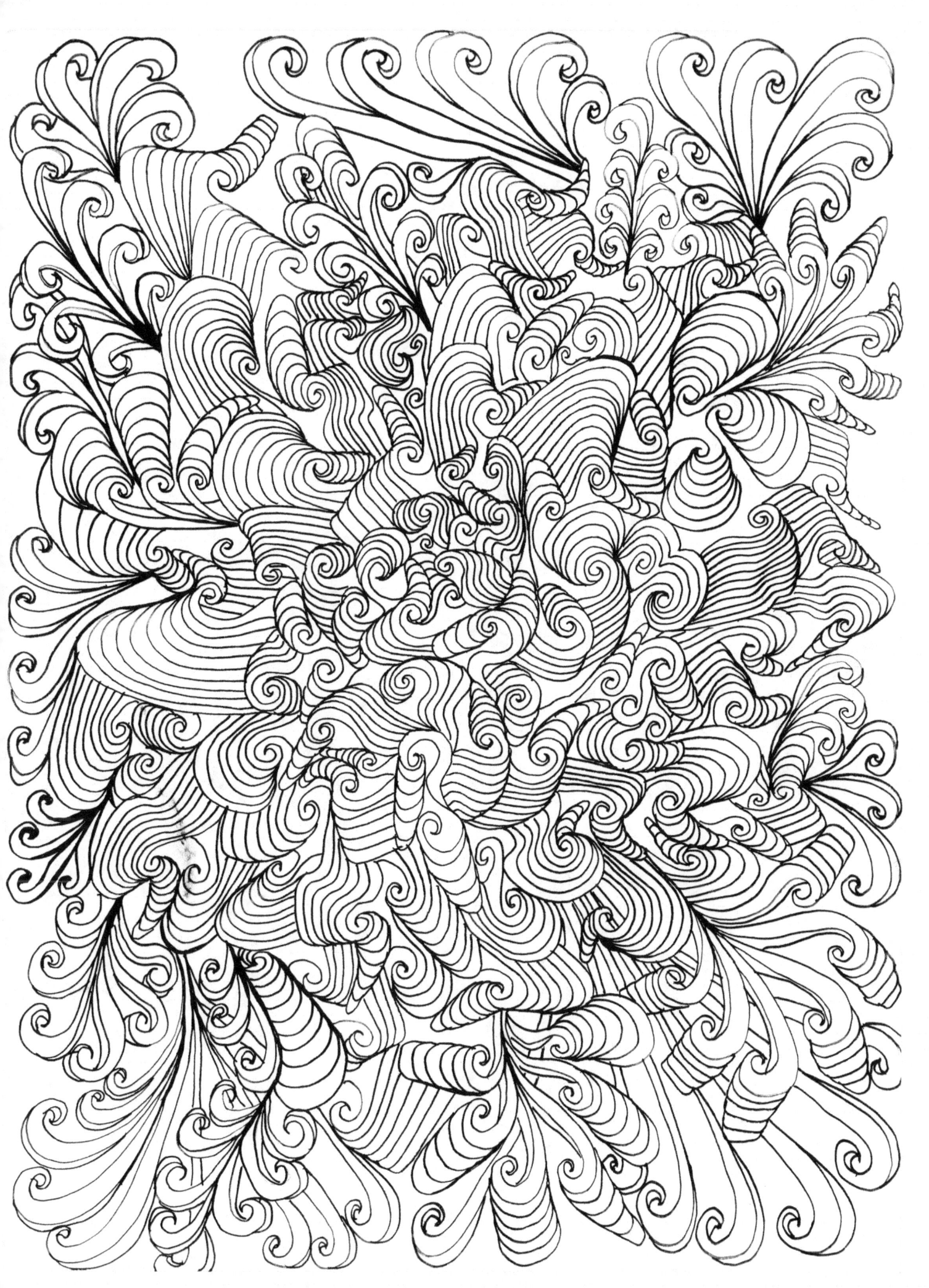

www.ingramcontent.com/pod-product-compliance
Lightning Source LLC
Chambersburg PA
CBHW080724190526
45169CB00006B/2505